ALVIN LANGDON COBURN
Symbolist Photographer

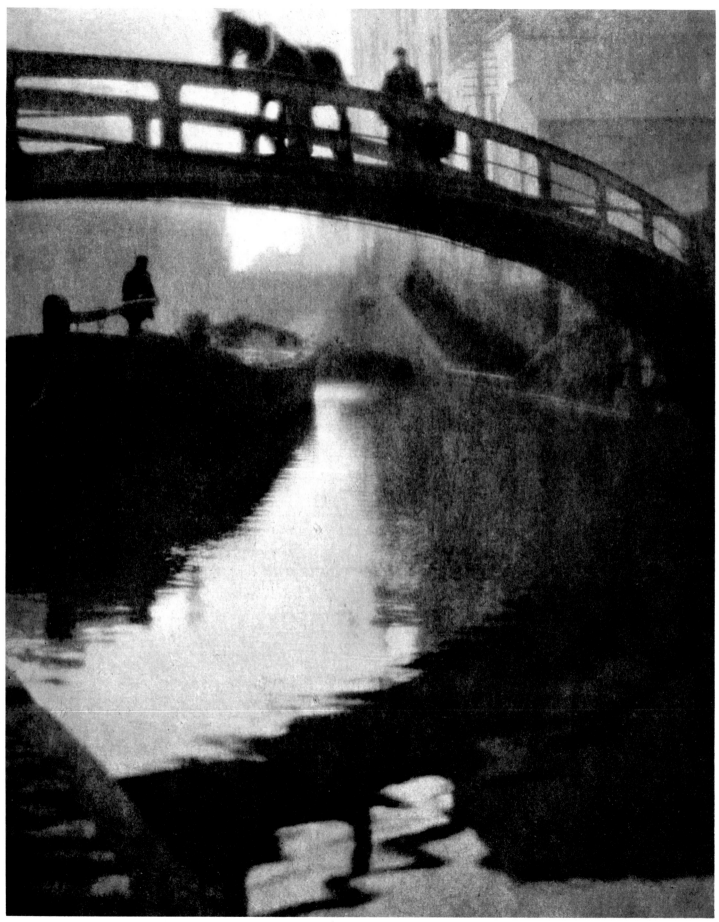

Regent's Canal, 1905 (Plate XII from *London* portfolio, 1909)

ALVIN LANGDON COBURN
Symbolist Photographer
1882-1966

BEYOND THE CRAFT
by MIKE WEAVER

AN APERTURE MONOGRAPH

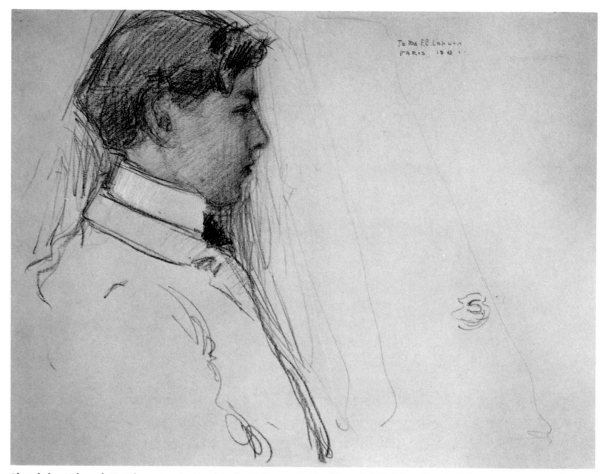

Sketch by Edward Steichen, *Portrait of A. L. Coburn,* 1901. Signed: "To Mrs. F. E. Coburn, Paris 1901."

ACKNOWLEDGEMENTS Aperture gratefully acknowledges the loan of prints from the Coburn Archive of the International Museum of Photography at George Eastman House and the cooperation of the Eastman House staff: Robert Sobieszek, Director of Photographic Collections; David Wooters, Chief Archivist; Carolee Aber, Mariann Fulton, Heather Alberts, and Rachel Stuhlman.

Special thanks are extended to: Bill Dworkin at Rizzoli International for Sesshū illustration; Ann Gaudinier at Kodansha International for Hiroshige's *Kyōbashi Bridge*; Charles E. Tuttle Co., Inc., for Hokusai's *Mt. Fuji from the Tōtōmi Mountains*; Éditions Albin Michel S.A. for Hiroshige's *Ferry at Haneda*; the Coburn Archive at Eastman House for Hokusai's *Dragon of the Storm,* Whistler's *Nocturne in Blue and Gold; Old Battersea Bridge,* Coburn's ink drawing for "Vortographs and Paintings" exhibition pamphlet, and Edward Steichen's drawing of Coburn; and Eileen Smith, whose research has been invaluable.

Composition by David E. Seham Assoc., Inc., Metuchen, New Jersey; Duotone negatives by Robert Hennessey; Printed and bound by Amilcare Pizzi, S.p.A., Milan, Italy. Library of Congress Catalog Number: 85-52455. ISBN: 0-89381-240-4, cloth edition; ISBN: 0-89381-246-3, museum catalog edition.

Aperture Foundation Inc. publishes a periodical, books, and portfolios of fine photography to communicate with serious photographers everywhere. A complete catalog is available upon request. Address: 20 East 23 Street, New York City, New York 10010.

This publication accompanies the exhibition of photographs by Alvin Langdon Coburn organized by the International Museum of Photography at George Eastman House.

Current Exhibition Schedule:

Cleveland Museum of Art
Cleveland, Ohio
July 22 - August 31, 1986

Huntsville Museum of Art
Huntsville, Alabama
September 28 - December 21, 1986

International Center of Photography
New York City, New York
January 1 - February 16, 1987

Lowe Art Museum
Coral Gables, Florida
March 4 - April 13, 1987

Elvehjem Museum
Madison, Wisconsin
May 16 - July 5, 1987

CONTENTS

THE MENTAL BASIS 6

THE JAPANESE INFLUENCE 11

THE SYMBOLIST ASPECT 23

THE ADVENTURES OF CITIES 33

THE OPERATIVE OR CRAFTSMANLY QUALITY 48

THE SPECULATIVE OR SECRET ART 51

BIBLIOGRAPHY 77

CHRONOLOGY 79

THE MENTAL BASIS

In their essential nature men do not change. The great and noble, the Masters of Life, will be great and noble to the end of time, and to contemplate them and their deeds inspires us to endeavour to emulate them. Learn whom a man venerates, and you can come to judge his character. Like is assimilated unto like. The mind approaches that which it continually contemplates, and kindred acts inevitably follow.—Alvin Langdon Coburn[1]

Alvin Langdon Coburn was born in Boston in 1882 into a solid middle-class family, but his father, a shirt manufacturer, died when the boy was only seven. This appears to have resulted in a degree of insecurity combined with indulgence that bound him too closely to his ambitious mother. (By his own admission, when his mother remarried he gave his stepfather considerable annoyance.) In 1890, the year after his father died, he visited his uncles in Los Angeles, and they gave him a Kodak. Much more significant was the gift that his distant cousin Fred Holland Day, the bibliophile, publisher, and photographer, made him in 1901—a copy of *Chambers Dictionary*.[2]

Coburn had crossed the Atlantic in 1899 with his mother to take rooms at 89 Guilford Street, Russell Square, London. Day was in Mortimer Street not far off, having brought over from the United States a huge selection of American photographs for exhibition at the Royal Photographic Society. There were one hundred three photographs by him, twenty-one by Edward Steichen, and nine by Coburn. Alfred Stieglitz had refused to take part, as there was rivalry and mistrust between him and Day. Mrs. Coburn's jealousy of Steichen failed to damage Steichen and Coburn's relationship, although it harmed Coburn in Stieglitz's eyes. Coburn studied in Paris with Steichen and Robert Demachy in 1901 before he and his mother went off on a tour of France, Switzerland, and Germany.

In 1900 Coburn had also exhibited with the Linked Ring Brotherhood, founded in 1892 by a group of photographers that included H. P. Robinson, George Davison, and H. H. H. Cameron, Julia Margaret Cameron's son. The three interlinked rings that were the symbol of the Brotherhood had Masonic overtones and probably referred to the triadic virtues of the Good, the True, and the Beautiful. (In 1927, when Coburn was made an honorary Ovate of the Welsh Gorsedd, or meeting of Druids, he took the Welsh name Maby-y-Trioedd, "son of the triads.") In 1900 too Coburn met Frederick H. Evans, the British photographer of cathedral interiors, who was also a "Link." It has recently been shown that Evans was a Swedenborgian like Henry James Sr., whose writings he admired.[3] Connections between European and American comparative religious thought were firmly established through Emerson, Whitman, Maeterlinck, and the James family. Coburn's later mentors, Edward Carpenter, Arthur Symons, and Henry James Jr. (the novelist), sustained this mental basis for him but also weaned him from the

Decadent influence of Fred Holland Day. That influence was probably more innocent than diabolical, and Coburn probably remained too boyish to fall wholly under his cousin's spell—there is no sign of homoeroticism in Coburn's work. He seems to have been more influenced by Day's maternal imagery than anything else.[4]

In 1902 Coburn opened a studio at 384 Fifth Avenue, New York, and studied with that great Madonna figure in the history of photography, Gertrude Käsebier. She probably encouraged his attendance at Arthur Wesley Dow's summer school in Ipswich, Massachusetts, which gave him the grounding in composition that was to underpin his own contribution to photography. But his conception of the craftsmanly ideal brought him back to London in 1904 to join Frank Brangwyn, an inheritor of the William Morris tradition. Through Frederick Evans he met George Bernard Shaw, and in the *annus mirabilis* of 1905 he got to know Henry James, Edward Carpenter, and Arthur Symons.

It is extraordinary how attracted—and attractive—Coburn was to his seniors. In 1907, when Shaw considered the twenty-four-year-old Coburn the greatest photographer in the world, Maeterlinck, Symons, Brangwyn, Stieglitz, and Day were in their forties, Shaw and Dow in their fifties, and James and Carpenter in their sixties. Coburn's sensibility was formed by people at least a generation older than himself, artists who had direct links with Aestheticism (Maeterlinck and Day), the Symbolist movement (James and Symons), and the socialism of William Morris and Ford Madox Brown (Carpenter and Brangwyn). Coburn was full of energy and ambition, so much so that his nickname in the Linked Ring, to which he had been elected in 1903, was "The Hustler." In 1906 he took up the study of photogravure and went to Paris, Rome, and Venice to work on the frontispieces for the New York edition of Henry James's novels. His travels continued to New York and Detroit in 1907 and Ireland, Holland, and Bavaria in 1908. In 1909 he set up presses in Hammersmith, London, to print his own photogravures for his *London* and *New York* portfolios.

In 1908, however, there had been some tart personal criticism of him in *Camera Work*:

Coburn has been a favored child throughout his career. Of independent means, he launched into photography at the age of eight. Gradually, and to the practical exclusion of

Observatory, California, 1911

everything else, he devoted all of his time to its study. Originally guided by his distant relative, Holland Day, he, at one time or another, at home or abroad—the Coburns, mother and son, were ever great travelers—came under the influence of Käsebier, Steichen, Demachy, and other leading photographers. Instinctively benefiting from these associations he readily absorbed what impressed itself upon his artistic self. Through untiring work, and urged on by his wonderfully ambitious and self-sacrificing mother, his climb up the ladder was certain and quick. Arriving, three years ago, in London, for a prolonged stay there, his sudden jump into fame through the friendship of Bernard Shaw is well known. Shaw's summing up of Coburn can be found in *Camera Work*, Number XV. No other photographer has been so extensively exploited nor so generally eulogized. He enjoys it all; is amused at the conflicting opinions about him and his work, and, like all strong individualities, is conscious that he knows best what he wants and what he is driving at. Being talked about is his only recreation.[5]

The author was probably Alfred Stieglitz. Coburn evidently thought so when he wrote to him in plaintive terms, not so much on his own behalf as to say that his mother (who was not too well, he said) had been upset by it.[6] The sly insinuation of the piece, which rose to heights of sarcasm to end in hollow eulogy, had, Coburn appeared to suggest, not touched the victim himself. Mrs. Coburn had trumpeted her son's work on every possible occasion, and Stieglitz evidently considered him a mother's boy. But perhaps what rankled most with Stieglitz was Coburn's alternative promotion of photography in Britain, including a new portfolio club, The Brotherhood, with George Davison, James Craig Annan, Baron de Meyer, and others. Although Coburn was always careful to see that Stieglitz was included in the British publications in which he had some influence, such as the *Studio* special issue *Art in Photography* (1905) and A. J. Anderson's *The Artistic Side of Photography* (1910), it would have been quite apparent to Stieglitz that Coburn was refusing to confront him while managing to keep his complete independence.

However, Coburn's conduct over the introduction of the Lumière Autochrome into Photo-Secessionist circles does seem to have been somewhat underhand. Having learned how to simplify the process in Steichen's darkroom in Paris while Stieglitz was present, Coburn jumped the gun by giving an interview to the press on color photography before Stieglitz could get back to America to call a press conference himself.[7] In an interview, Coburn gave the impression that he was the sole person qualified to use the new process. He did mention Frank Eugene and Steichen, but that would have only enraged Stieglitz further because he was the one who had initiated Eugene in Autochrome work. Coburn was something of a hustler, after all. From a more tolerant point of view, he was only twenty-six years old and still did not know how to behave. The young man with the Latin Quarter beard appeared opinionated, facetious, and overconfident, whereas he was really emotionally very immature. How could Shaw have described him as a "specially white youth," and Stieglitz as "tricky"?[8] Well, he was divided in himself

between altruism and ambition—not so uncommon at that age.

Coburn's essential nature had yet to be clearly brought out from under the pressures of immaturity and precociousness. In 1904, when Coburn was only twenty-two, J. B. Kerfoot, one of the editors of *Camera Work*, caricatured him as young Parisfal, "pouting because the Holy Grail eludes him."[9] Sadakichi Hartmann, the greatest of all photography critics, remarked on the physical resemblance between Coburn and Emmanuel Signoret, editor of the Symbolist magazine *Le Saint-Graal* (1892–99).[10] The quest for religious truth implied in pursuit of the Grail was firmly attached to people's idea of Coburn. They saw him as a holy innocent, somewhat spoiled by his mother. In short, the ethical basis of his life was not yet developed—social acts kindred with his high ideals had not yet followed in the wake of his status as an infant prodigy.

Coburn shared the same difficulties as two or three previous generations of Americans. It seemed to them that there was not much in American society to help them mature as human beings, and so they went to Europe. Once there, T. S. Eliot turned to the Anglican Church for spiritual help, and Ezra Pound looked to systems of education. Coburn turned to the orders of chivalry in his pursuit of the Holy Grail, and, after 1919, to Freemasonry, which was the logical extension in the British context. The local people who knew him in North Wales in the forties saw him as a stalwart of the local dramatic society in Harlech, as an active Freemason, and as Head Store-Keeper of the Joint County Committee of the Red Cross Society and St. John Ambulance who turned his house into a fifteen-bed hospital during the war. It is very hard to recognize as the same person the young man in the Whistlerian top hat and the vegetarian who kept goats and whose hobbies were walking, cycling, and gardening.

The mental basis of Coburn's life was committed to hidden or ideal philosophy from his beginnings as a "young Parsifal" in 1904 to his Grand Stewardship of England in the Allied Degrees of Masonry in 1930. But it is possible to identify certain phases in his life as of special significance. The years 1900–1905 were his apprenticeship; 1905–10 was his Symbolist period, in which he made his great contribution to photography; 1916–23—years that Coburn himself described as wasted—saw him in confusion, dabbling in astrology and the occult; 1923–30 was the period when he became completely devoted to the life of the Universal Order, a comparative religious group that had begun in 1911 as the Hermetic Truth Society and the Order of Ancient Wisdom. Its quarterly magazine, *The Shrine of Wisdom*, began publication in 1919, the same year Coburn became a Mason. To read this magazine over a nearly thirty-year period is to get a very clear idea of Coburn's beliefs.[11] The man who changed his life from 1923 on was the unnamed leader of the group,[12] and Coburn's solidity as a citizen and the falling-away of all mundane ambition thereafter was due to his direct influence. The Universal Order provided the background for activities as a Rosicrucian, a Druid, and a Freemason. Coburn had added Druidism, the Welsh religion, to his interests as early as 1916, when his visits to George Davison, the photographer and philanthropist, in Harlech had introduced him to the composers Sir Granville Bantock, who shared his Druidical interests, and Cyril Scott, who was an active Theosophist. Coburn toured the great mega-

lithic sites of Stonehenge, Glastonbury, and Avebury in 1924 and photographed the stone circles in 1937. His interest in ancient British religion was constant over a long period. In 1938 he wrote a play, *Fairy Gold*, with music by Bantock, which was Druidical in spirit but modeled on the Belgian mystic Maurice Maeterlinck's play *The Blue-Bird* (1909), which Coburn greatly admired. His interest in Freemasonry predated his initiation in 1919—the fifty books by A. E. Waite on his shelves covered a range of interests from the Holy Grail to the history of the Masonic and Rosicrucian orders. Waite's introduction to a little German work, *The Cloud upon the Sanctuary*,[13] may have been as influential on Coburn's cloud photographs as Yoné Noguchi's book *The Summer Cloud* (1906). So far as Coburn was concerned there was no difficulty in embracing East and West, ancient and modern, simultaneously. In 1927 he became a Druid; in 1928 he began his long study of the Chinese Taoist classics in the British Museum Library; in 1935 he became a lay reader in the Anglican Church in Wales; and by the forties he was a prolific speaker and writer on Masonic subjects.

It is possible to see 1928–30 as watershed years. Coburn's mother died; he lost all his beloved Pianola rolls in a flood; he gave his collection of photographs to the Royal Photographic Society, destroyed fifteen thousand negatives, and moved from London to North Wales. In 1930 he was still only forty-eight, but his life from beginning to end was one of overlapping circles of interest linked forward and backward simultaneously; his basic inclinations never changed, only the external conditions.

External conditions are, however, crucial in the accurate description of Coburn's contribution to photography. What makes him a great photographer is that his Symbolist period, 1905–10, provided him with the four factors necessary to a photographer who wished to advance the art: the philosophical basis (comparative religion), the aesthetic basis (Japanese art), the technical basis (the telephoto lens and the soft-focus lens), and the craftsmanly basis (photogravure). Such factors determine the contribution of any great photographer (for example, for Julia Margaret Cameron the bases were Christianity, Dutch and Italian art, the selective-focus lens, and the albumen print). The mental basis of the photographer may not change, but the conditions under which he or she works do. There is the moment when everything comes together, which then passes. Most artists do not survive the moment as artists. Only those of extraordinary capacity to adapt to new conditions have several such creative moments. These are artists of genius like Stieglitz, Steichen, and Paul Strand. The merely great artists have only one such period: Julia Margaret Cameron (1864–74), Frederick Evans (1900–1911), Edward Weston (1927–37). Coburn, like them, had one (1905–10, extendable to include the Yosemite and Grand Canyon pictures). Then he got married, returned to England, and photographed only intermittently.

To include the month-long Vorticist instant of his career is logical from the modernist historian's point of view. In January 1917, under the influence of London's response to Cubo-Futurism, Coburn lashed together three of Ezra Pound's shaving mirrors, rigged them below a kind of glass lighttable, and produced his Vortographs. These have taken their place in the history of abstract photography with Man Ray's Rayographs, Christian

Schad's Schadographs, and the light experiments of Moholy-Nagy. That Coburn's kaleidoscopic efforts preceded those of others by a year or two has tended to propose his significance to the history of photography as an avant-gardist and early modernist, when in fact his major contribution was symbolist and impressionist. By 1917 external conditions had changed dramatically: modernism, optical experiment, and bromide papers had succeeded *japonisme*, Symbolism, soft-focus lenses, and photogravure and put Coburn out of step. Steichen's response to the crisis of modernism was different. He turned to studies of forms in nature under the influence of Theodore Andrea Cook, the English morphologist,[14] whereas Coburn was sucked briefly into the Cubo-Futurist vortex.

Coburn's taste in music enshrined Wagner and Sibelius, but he asked himself whether there was a future for him alongside Stravinsky and Schoenberg as he himself began to punch abstract patterns into a Pianola-roll-cutting machine to see what came out:

> Yes, if we are alive to the spirit of our time it is these moderns who interest us. They are striving, reaching out towards the future, analysing the mossy structure of the past, and building afresh, in colour and sound and grammatical construction, the scintillating vision of their minds; and being interested particularly in photography, it has occurred to me, why should not the camera also throw off the shackles of conventional representation and attempt something fresh and untried? Why should not its subtle rapidity be utilised to study movement? Why not repeated successive exposures of an object in motion on the same plate? Why should not perspective be studied from angles hitherto neglected or unobserved? Why, I ask you earnestly, need we go on making commonplace little exposures of subjects that may be sorted into groups of landscapes, portraits, and figure studies? Think of the joy of doing something which it would be impossible to classify, or to tell which was the top and which the bottom![15]

Of course a modernist camera vision can abnegate reality, indulge a desire to manipulate reality, destroy perspective altogether, and discard traditional genre subjects, but the joy of losing all orientation with regard to human reality is ultimately illusory and sterile. It is especially perverse when the camera and film and photographic paper, the most efficient combination in the rendering of realistic surfaces, are used to fulfill a modernist commitment to abstraction.

When a young person, spiritually alive but not consciously enlightened, approaches the phenomenal world without studying it so much as intuitively responding to it, the making of art is always possible. But when this same person becomes a fully trained mystic the manifested universe is seen in increasingly ideal terms—as material for a science of ideas rather than an art of symbols. In order to remain an artist this person must not pass so quickly from the visible to the invisible world that there is no physical sign left to commemorate the adventure with mundane reality.[16]

The approach taken in this essay focuses on Coburn's Symbolist period, when he considered art neither entirely naturalistic nor wholly abstract but generally symbolic.

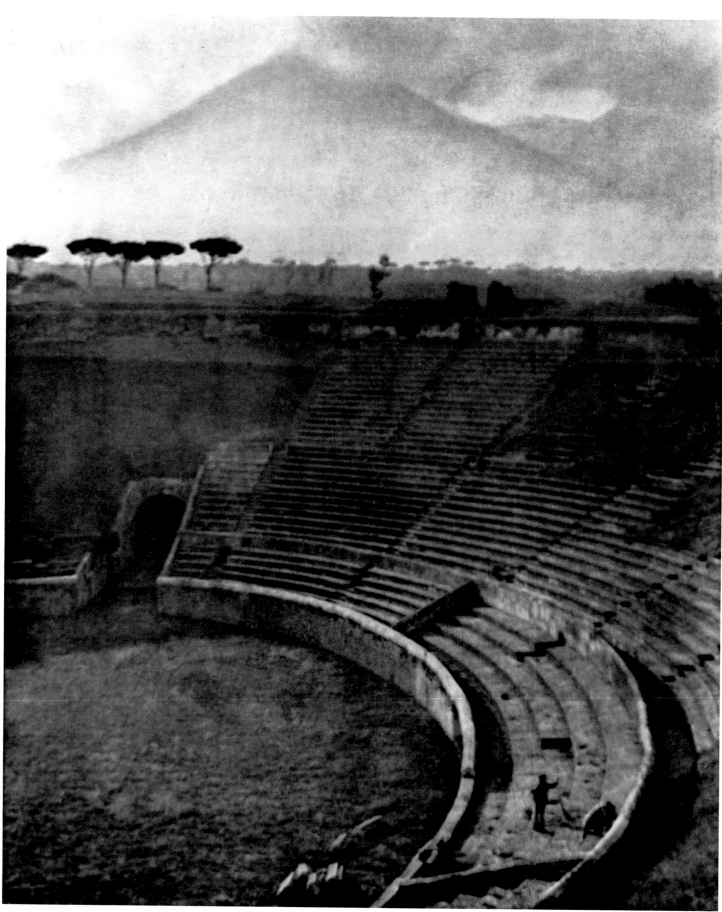

Vesuvius, 1905

THE JAPANESE INFLUENCE

One of the conditions of harmony in architecture, as in life, is to avoid the monotony of regularity and excessive repetition. Exact equality of division lacks mystery. A rhythm that may not be completely fathomed, a beauty that eludes the mind's grasp yet is manifestly of exquisite proportions, this is the secret of the marvellous power of the progression of the Golden-mean.—Alvin Langdon Coburn[17]

In the nineties Ernest Fenollosa and Okakura Kakuzo, first in Tokyo and then in Boston, were competing for the honor of being responsible for the revival of Japanese wood-block printing. Okakura was the author of books on the ideals of the East—such as *The Book of Tea* (1906), which placed Japanese art in relation to Taoism and Zen. The hero of this Boston circle, which was associated with the Department of Chinese and Japanese Art at the Museum of Fine Arts, was the fifteenth-century Zen painter Sesshū, to whose work Coburn was also devoted. Outside the museum's collection it was almost impossible to see Sesshū's work except in the pages of *Kokka*, the magazine of the Japanese cultural revival. But through Arthur Wesley Dow, Coburn had an entree not only to Sesshū, whose splashed-ink technique Dow imitated, but to the museum itself, where Dow had been Fenollosa's assistant curator and had an exhibition of his own prints in the Japanese corridor. Coburn educated himself in this milieu concerned with East–West relationships in art and religion and studied with Dow at his Ipswich School of Art. He spent two summers with Dow—the first on his return from Paris to New York in 1902, the second in 1903—studying stenciling, pottery, and design. In New York he worked with Gertrude Käsebier, who was Dow's colleague at the Pratt Institute in Brooklyn.

Arthur Wesley Dow was the foremost art teacher in America. His great manual, *Composition*, with a foreword by Fenollosa, began its publishing life in 1899 and ran through twenty larger and larger editions in the next forty years. Dow also published *Ipswich Prints*, wood-block color prints that revived the classic Japanese techniques of the mid-nineteenth century. From his studio window Dow made a woodcut called "The Green Dragon," and Coburn copied it in photography. Coburn's wish that he could have followed Hiroshige along the Tokaido Road and his emulation of Dow's similar progress along the Ipswich River invite us to consider his own poetic topography of the Thames in this tradition. In August 1903, when a Japanese student at Dow's summer school mounted an exhibition of prints by Hiroshige and Hokusai in Emerson Hall, the ancestral home of Ralph Waldo Emerson, there was also an exhibition of a group of photographs by Coburn.

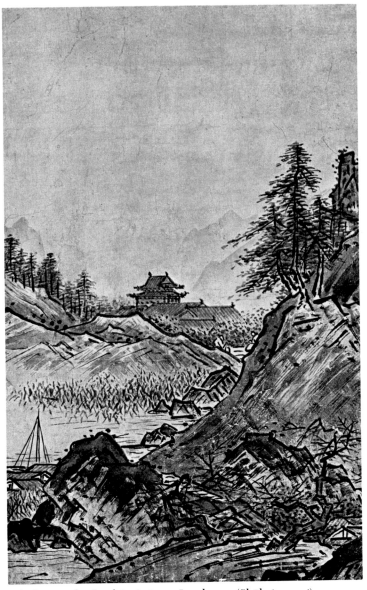

Ink drawing by Sesshū, *Autumn Landscape* (Shūkei-sansui)

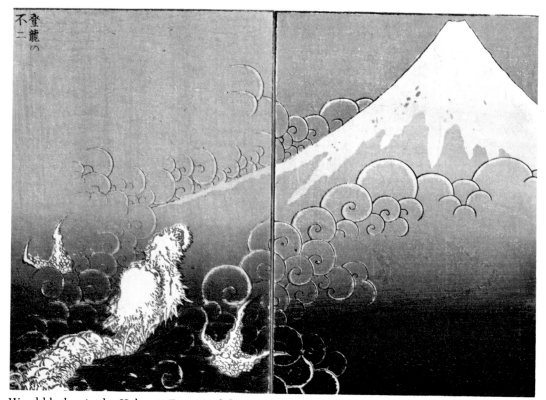

Wood-block print by Hokusai, *Dragon of the Storm* (From *One Hundred Views of Fuji*, vol. 2, 1835)

The influence of *japonisme* was felt everywhere by now. It was deeply implanted in the minds of the French Impressionists by the 1880s. It had penetrated England through Whistler and Scotland through the Glasgow Boys (George Henry and E. A. Hornel) and Frank Brangwyn, the English painter-etcher who was to be Coburn's next teacher. Among the graphic work in Coburn's collection at George Eastman House are prints by D. Y. Cameron, James Craig Annan's etcher friend, who was influenced by *japonisme,* and a reproduction of Whistler's *Old Battersea Bridge*, which Sadakichi Hartmann rightly considered a copy of a Hiroshige composition, "Kyōbashi Bridge, Edo." Hartmann wrote a book on Japanese art in 1905, and when Coburn made his portrait of this actor and critic, he did it in the form of a Japanese mask, an image even more striking than the print he made in homage to the actor Micha Itow at the height of the vogue for No plays in London.

Coburn's later relations in London with Edmund Dulac, designer of Kabuki-style masks for Yeats; Yoné Noguchi, author of several books on the Japanese wood-block illustrators, who as a poet wrote on the Yosemite Valley; and Charles Shannon and Frederick Evans, both of whom had fine collections of Japanese prints, confirmed his lifelong interest in Oriental art. The biggest regret of his photographic life as a portraitist was that he had missed Lafcadio Hearn and Whistler.[18]

Hartmann observed that Japanese landscapes seemed to be painted from an elevation and with mountains towering behind one another. Any difficulties of perspective from the Western point of view were avoided by the judicious introduction of clouds. Hartmann attributed all kinds of characteristics of modern art to the Japanese influence: parallelism of vertical and of horizontal lines, eccentric and asymmetrical composition and new space composition in general, the aerial treatment of aspects of nature. He deplored the superficial copying of Japanese methods: Western artists should study the Japanese laws of construction.[19] But Fenollosa and Dow had done this. Moreover, they went deeply into the philosophical nature of Japanese culture, as their commitment to the magazine *Kokka* showed. They wanted to assimilate the Eastern religious tradition in their own. In this Coburn followed them far more seriously than Hartmann or anyone else could have anticipated.

Dow taught the principles of composition that Coburn came to adopt. Insofar as Dow aimed to teach art through composition rather than by academic drawing, what he offered was especially useful to the photographer.[20]

> Schools that follow the imitative or academic way regard drawing as a preparation for design, whereas the very opposite is the logical order—design a preparation for drawing.

Unfortunately, imitation of nature was usually preferred to imaginative composition. Dow acknowledged that it was Fenollosa who had convinced him that composition or space art was a kind of visual music, and with Fenollosa's encouragement Dow prepared his first course of exercises in line, *notan* ("dark-and-light"), and color. These were the three elements of composition. By "academic" Dow meant teaching based on a theory of representation rather than of abstract design, so the craftsmanly life at Ipswich, with Coburn dressed for the job in the blue smock of the peasant or the white smock of the butcher, concentrated on the nonrepresentational arts of pottery, metalwork, and textile design. In areas confined to nonrepresentation, less

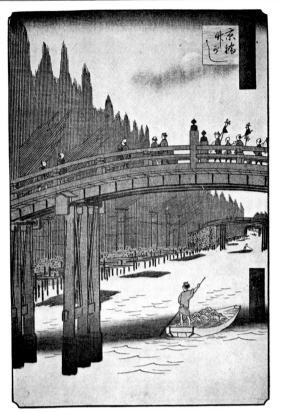

Wood-block print by Hiroshige, *Kyōbashi Bridge*
(*One Hundred Views of Famous Places in Edo*, 1858)

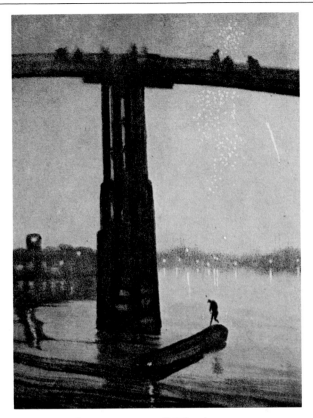

Oil painting by James McNeill Whistler,
Nocturne in Blue and Gold: Old Battersea Bridge

prejudice arose in the student's mind about what was good composition.

A picture, then, may be said to be in its beginning a pattern of lines. Could the art student have this fact in view at the outset, it would save him much time and anxiety. Nature will not teach him composition. The sphinx is not more silent than she on this point.

By bringing together the idea of the representational picture with that of abstract pattern in nonrepresentational crafts, Dow encouraged the discovery of structural or synthetic similarities in both. The crafts had been wrongly reduced to the status of "decorative," as if any form of composition that did not attempt the illusion of three dimensions was less than art.

Composition by line and composition by mass were described in Dow's terms as "spacing" and "*notan.*" In more conventional terms, this was linear perspective depending on the lines of drawing, and perspective depending on tints, washes, or colors. Dow's publisher had argued with him over "spacing," insisting that Dow really meant "composition" and Dow insisting that he did *not* mean Western linear perspective. The publisher also complained about "dark-and-light," saying that Dow meant "chiaroscuro"; Dow insisted that he did not mean the three-dimensional shading of a picture and instead employed Fenollosa's term, "*notan,*" to refer to graphic, rather than illusionistic, dark-light relations.

"Spacing" did not mean the effect of distance on heights, widths, and angles, any more than "*notan*" meant the effect of distance on tone or on clarity of outline. This was Western perspective based on simulations of the effects of binocular vision on objects at different distances; Japanese composition appears based on monocular vision, like the camera. Dow devised exercises in which vertical tree shapes were cut at right angles by the horizon to make varied patterns of rectangular spaces in two dimensions. He arrived at abstract relations between such spaces by simplifying arrangements and eliminating detail. His designs drew upon the vertical and horizontal formats of Japanese screen and scroll painting.

The creation of triangular arrangements of greater or lesser degrees of shallowness by means of variations of vertical and horizontal relationships within the frame can be seen in Coburn's "Hyde Park Corner." At its most sophisticated this use of spacing went beyond abstract design to suggest a meaning of the sublest kind, as can be seen in Coburn's handling of the Flatiron Building. When we compare it with a version of the same subject by Alfred Stieglitz we find that Stieglitz used the antirecessive device of a tree to suggest a relationship between the building and the tree by the analogy of the fork in the tree's branches. But Coburn provided an abstract solution to the problem of indicating the triangular nature of the building by creating shallow angles of incidence between the line of trees and the building and between the top of the building and the sky. Stieglitz proposed the forked tree as an overtly symbolic device; Coburn offered a compositional analogue of the building's structure.

Such antirecessive devices also came from Japanese art. When a Hokusai print showed a man cutting planks from a log that divided the image into two triangles, the supports for the log were also almost triangular, and between them was the shape of Mount Fuji.[21] The oblique and antirecessive structure

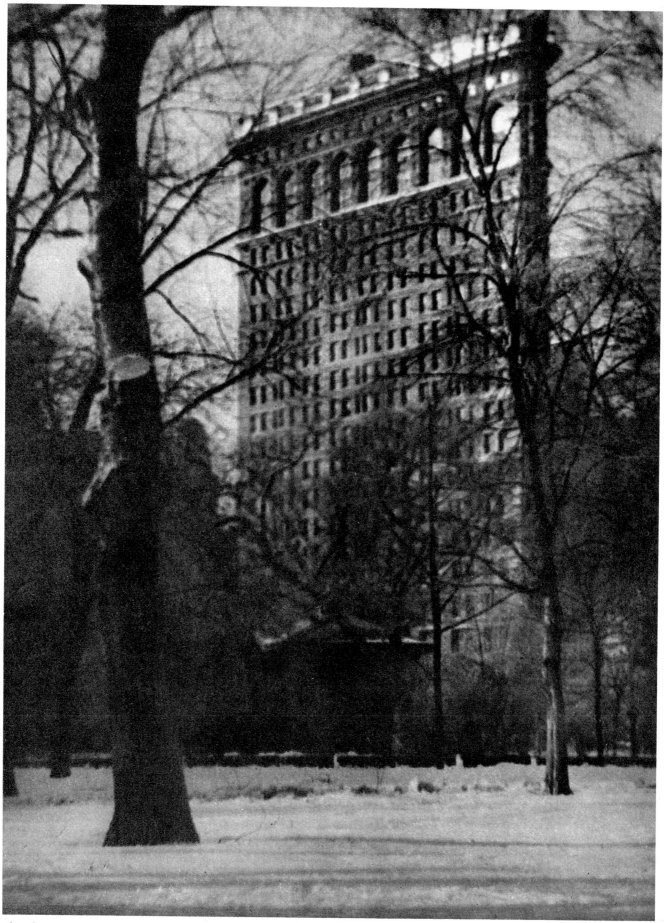

The Flat-Iron Building, 1909 (Plate VIII from *New York,* 1910)

Hyde Park Corner, 1905 (Plate V from *London,* 1909)

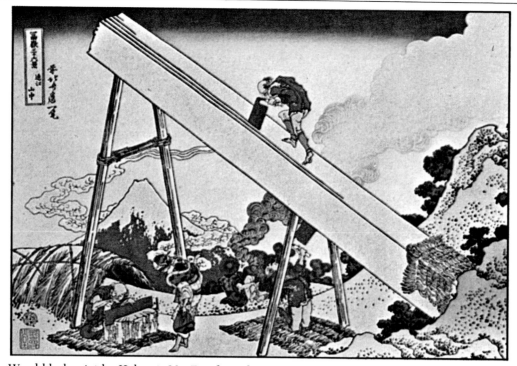

Wood-block print by Hokusai, *Mt. Fuji from the Tōtōmi Mountains*
(From *The Thirty-six Views of Mt. Fuji*, 1823-31)

of the log was a compositional analogue for the holy mountain. In Coburn's "Williamsburg Bridge" the antirecessive crossbars overlap the span of the bridge to form several nearly triangular spaces.

The Japanese written character for "perspective" is a combination of "near" and "far" and, unlike the Western idea of one thing being seen *through* another, implies an overlay of one thing *on* another in the same plane. But because Japanese pictures seem to be made from an elevation, the effect is less of superimposition in the Western sense than of superposition, pillarwise, so that elements are read upward or downward over the two-dimensional surface of the picture. In order to increase the range or depth of field so that a view could include close peaks and distant mountains, the Japanese artist raised the horizon. At the same time, objects and people in the immediate foreground were drawn as if from eye level. It is as if the Japanese eye had learned to develop a very long focal length so that deep space was telescoped and shallow space silhouetted.

In 1904 Thomas Dallmeyer, lens maker and the author of *Tephotography* (1899), made a telephoto lens for Coburn, who wrote to Stieglitz that he could now photograph the urban landscape in London usefully over distances of half a mile.[22] The relation between the telephoto lens and Japanese spacing is not obvious until it is realized that telephotography also flattens perspective so that the near and the far are piled one above the other apparently in the same plane, with the middle distance either eliminated altogether or stacked in between. Dallmeyer's scientific book took little acccount of the aesthetic implications of his invention, although he did cite Demachy as someone who had written about its uses. And Dallmeyer offered illustrations of what it could do.[23] In one he showed a whale skeleton on a seaside pier, which an ordinary lens made it impossible to comprehend by distorting the perspective. The same lens used from

the shore more than three hundred yards away reduced the skeleton to total insignificance. But with the new telephoto lens an image was obtained that gave the true proportions of the skeleton calibrated against the ironwork of the pier. Coburn may have seen the aesthetic possibilities of this telephoto view: a band of gray and a band of white intersected by the abstract patterning of the struts and pillars of the pier, and the sea reduced to an even tone—a gray zone. Furthermore, a little pavilion some ten yards distant from the whale appeared to be within its jaws. Objects could be conceptually joined by contiguity to create new meanings.

A small folder of Coburn's snapshots (now at the Museum of Modern Art in New York), which he gave to the Whistlerian painter Leon Dabo, illustrates how he rephotographed subjects according to Dow's method from such hand-camera sketches. To compare the printed version of the garden at Moor Park with the snapshot view is to notice how a grassy incline has been turned into a flat space between rough deciduous trees on the high horizon line and manicured cypress tress in the foreground. The gap between is an imaginative space that causes the trees to rhyme with each other across the space and leads us to meditate on the relation of the natural to the artificial.

Among the Hiroshige prints that Coburn would have known is one of an incomplete oarsman whose figure obtrudes into the frame as a leg and an arm. A temple hidden in the trees is the ostensible subject of the picture, but the design emphasizes limbs and rope. In Coburn's "Wapping" the bowsprit juts across the frame in a similar way, the man leaning on his oar in line with it.[24] The space between these near elements and the far shore with its vertical stack is seen less as water than as a graphic interval, and the high horizon line tends to build the image vertically by suppressing our feeling of receding distance. In Hiroshige's famous "The Great Bridge in a Cloud Burst"[25] Coburn

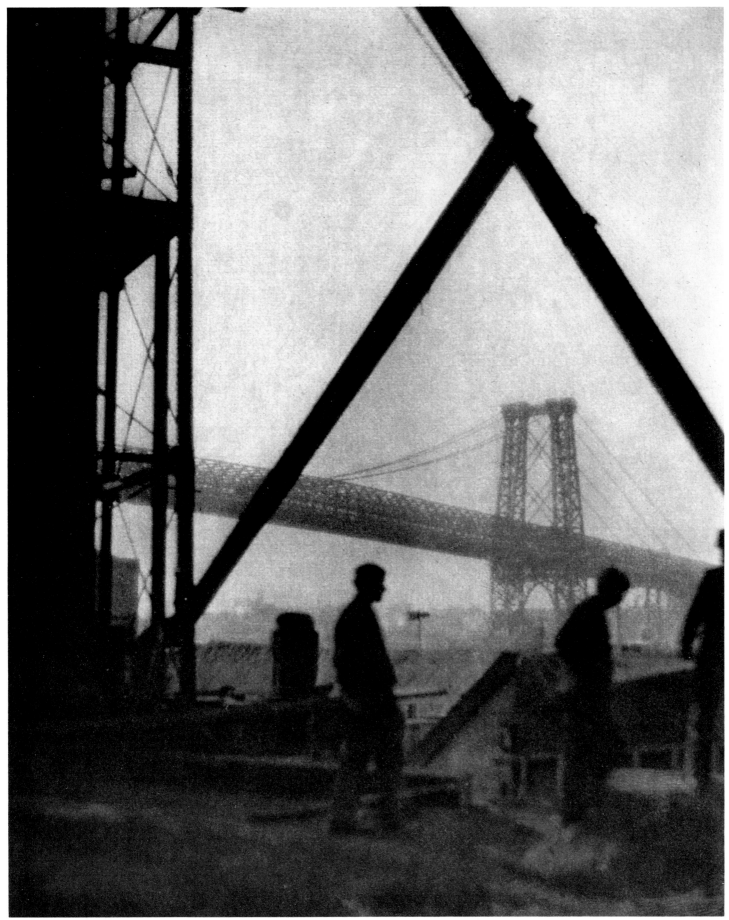

Williamsburg Bridge, 1909 (Plate IV from *New York,* 1910)

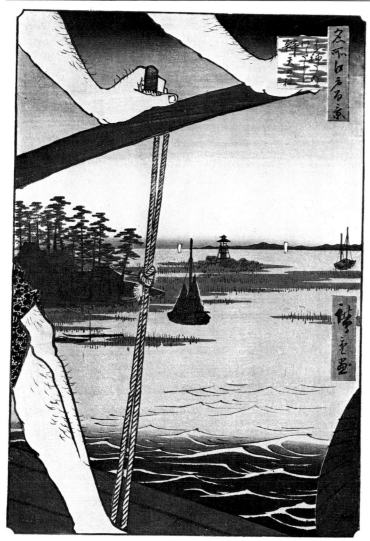

Wood-block print by Hiroshige, *Ferry at Haneda*
(From *One Hundred Views of Famous Places in Edo*, 1858)

graphic positive and negative reversals, but they are in fact exercises in *notan* in two values:

> Now we must think in different degrees of Notan—the "value" of one tone against another. . . . The word "values" refers to harmony of tone-structure; the value of a mass is its degree of light or dark in realtion to its neighbours.

He offered exercises on a scale of black, middle gray, and white, for *notan* in three values, and so on up to the seven values of a kind of zone system. Color, though different from *notan*, could be harmonized in flat tones the same way. Coburn's watercolors, often views of Harlech Castle painted as if they were studies of Mount Fuji, employed reds and purples and greens the way Hiroshige painted a mountain on the Tokaido Road in blues, blacks, greens, and yellow.[26] Coburn's "Half-Dome" is a study in *notan* of several values, including in the ravine a splashed-ink effect in the manner of Sesshū.

In 1910 Dow wrote to Coburn thanking him for some prints, which he described as "perfect in 'notan.' "[27] In June and July 1911 Coburn was in the Yosemite Valley, and from September 1911 to January 1912 in the Grand Canyon. Dow was in Los Angeles on his half-year sabbatical from Columbia Teachers College, and the two men went to the canyon to photograph together. Dow's own interest in photography went back at least to 1894, when he photographed a Monetlike haystack with its reflection in water. He thought the Grand Canyon so grand a subject that it would modernize his painting, which by 1911 was regarded as somewhat outmoded. Although he did not propose any symbolic characteristics for *notan*, believing that "synthetically related masses of dark and light convey an impression entirely independent of meaning," for Coburn all effects, even transient natural ones, evoked a spiritual meaning as well as producing a decorative or formal pattern. Dow acknowledged that the purpose of landscape art was to express emotion, but Coburn valued it for its powers of spiritual awakening. As a student of Lao-tzu, Coburn knew that landscape was not just a symbol of Tao but the substance of Tao itself. In the end Coburn was more Taoist than Dowist in his beliefs.

In 1910 Coburn helped the Engish critic A. J. Anderson with his fine book *The Artistic Side of Photography*. Anderson discussed the question of Japanese influence with his usual good sense. Flat-toned wood-block printing was inevitably decorative rather than naturalistic, he suggested. On the other hand, because of its emphasis on an impressionist rendering of gradations of light, Japanese painting was nearer photography than any other kind of art:

> . . . the definition of detail is strongly reminiscent of the definition of a photographic lens, working at a large aperture; there is an accentuation of a little clear detail at the point of interest, combined with great simplicity in the rest of the picture.[28]

What Coburn learned from the British tradition in art and photography was that photography's spiritual emphasis on breadth of effect was compatible with Japanese art, which had deep religious significance. No natural object, even in the industrial world, need be unharmonious or ugly, so long as it was viewed from the right angle of vision and in the right light.

would have been interested in the comprehensive diagonality of the image, the series of near-triangular forms created by the curve of the bridge and the tilted horizon, and the angle of the raft in the space between them. In Coburn's "The Ferry, Liverpool" the wake of the ship, the least permanent aspect of the scene, defines the difference between the stationary bollard and the moving funnel. The band of white is a symbolic space rather than the result of the action of the ship's propeller and articulates Coburn's concern with the relation between fixity and flux. Light and shade were also symbolic elements to be articulated to express relations between permanence and change. To balance masses of tone was as important as balancing elements of line. Divisions of space had to be related to tonal effects.

Exercises in *notan* formed the core of Dow's book. In Coburn's "The Castle from the Vennel" the emphasis is not on the great fortress, which is barely visible, but on the silhouetted houses and those curious, obtrusive poles on which the citizens of Edinburgh hang their laundry out to dry. It is a study of the Dow kind, almost positive-negative in both tone and line, as can be seen by imagining the black space on the left inverted and reversed to fill the space the castle occupies. A first glance at Dow's exercises in *notan* suggests that they are based on photo-

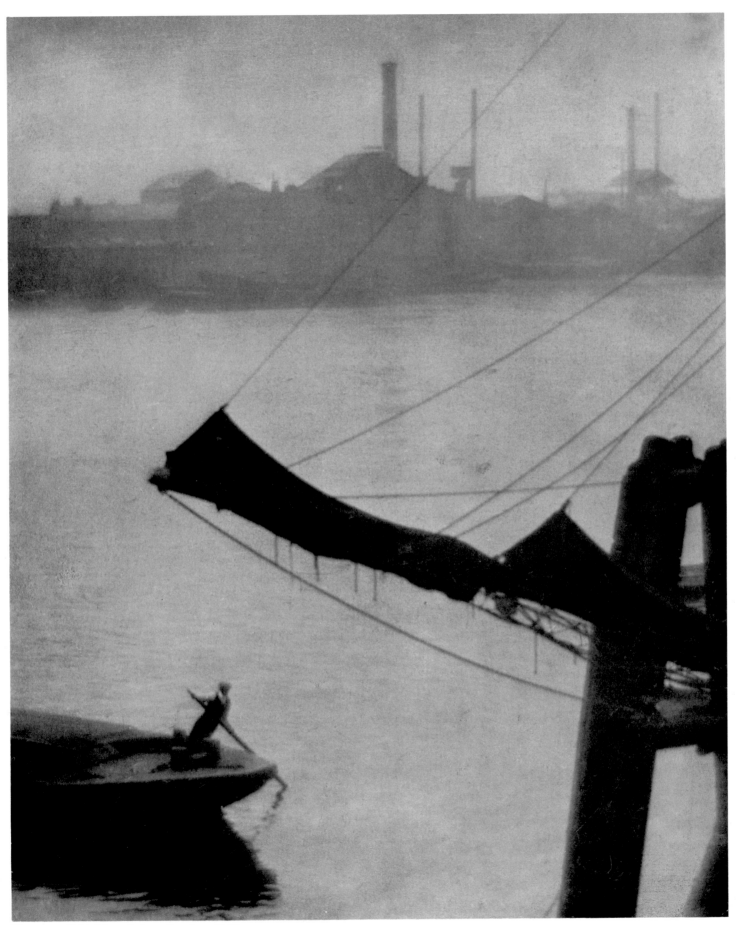

Wapping, 1904 (Plate X from *London,* 1909)

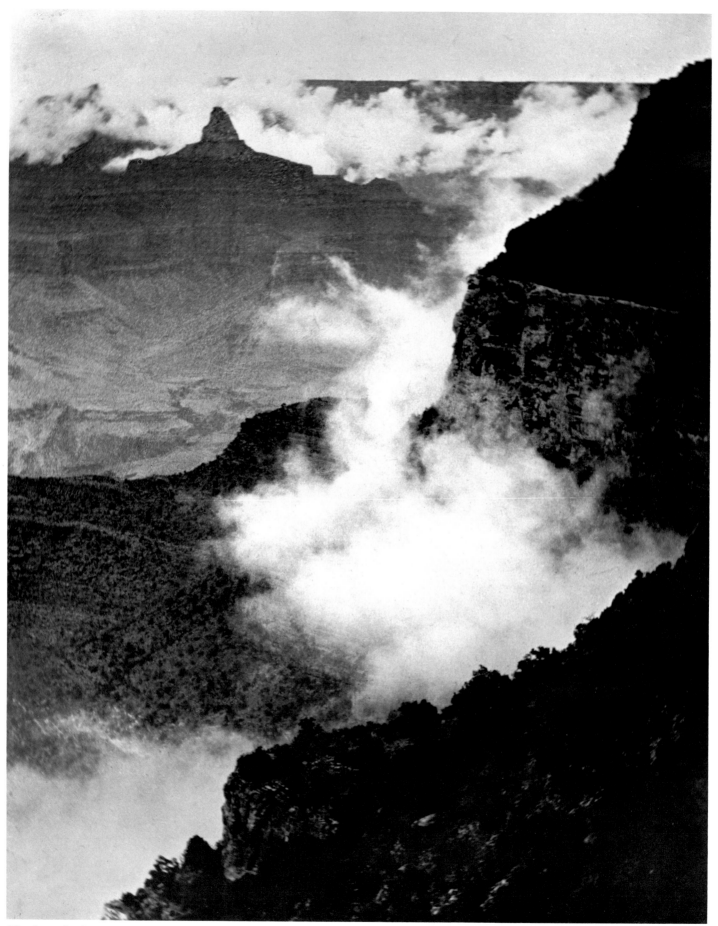

Clouds in the Canyon, 1911

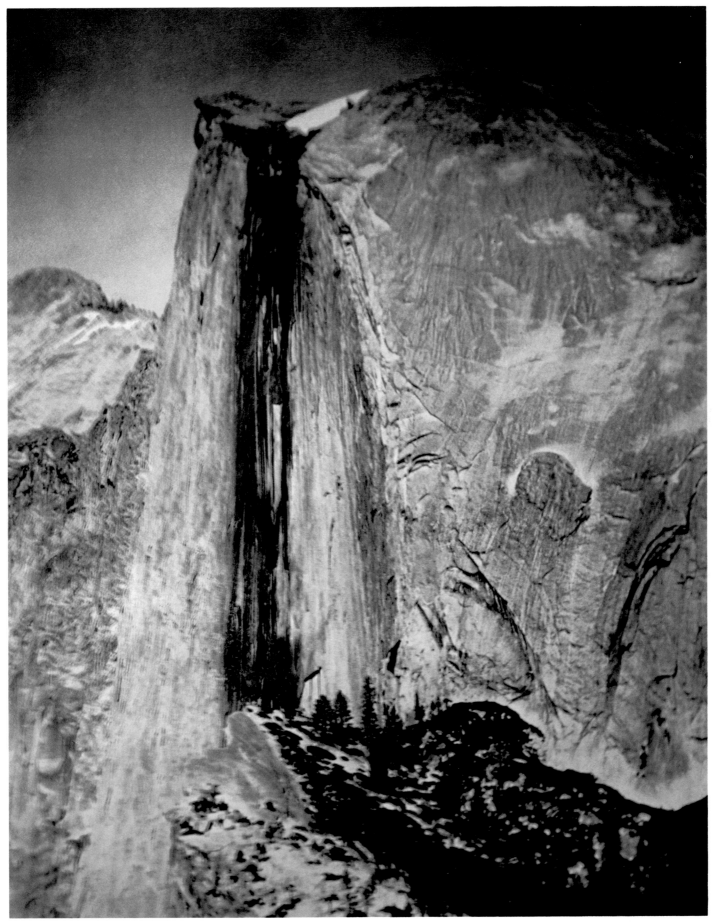

The Half Dome, Yosemite National Park, 1911

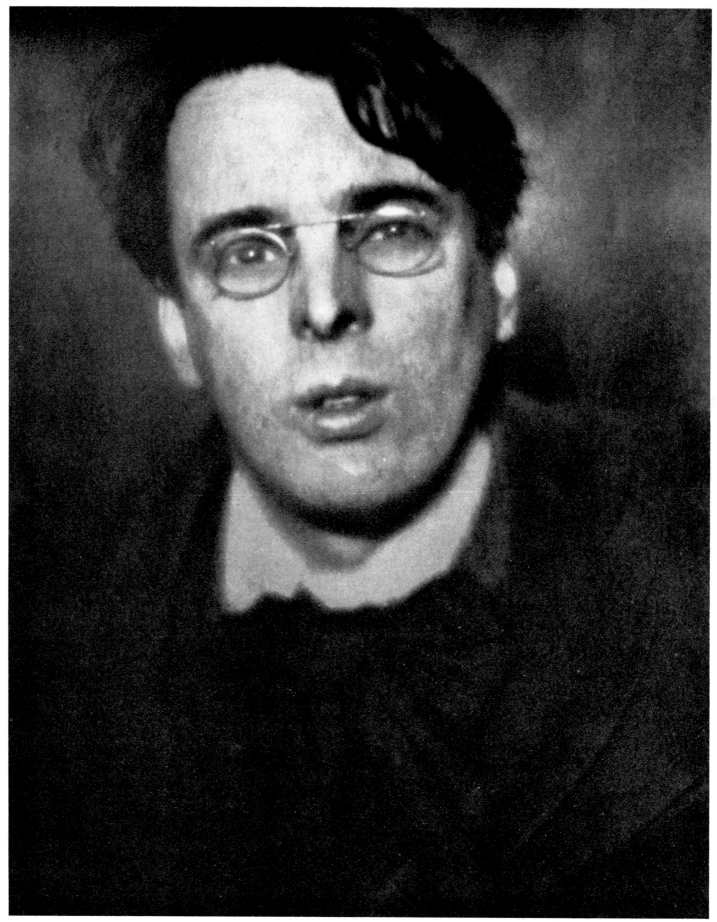

W. B. Yeats, Dublin, January 24th, 1908 (Plate XIX from *Men of Mark*, 1913)

THE SYMBOLIST ASPECT

Symbols are of two kinds, Natural and Artificial. All the animals, plants, minerals, the orbs in space, day and night, sunrise and sunset, the very atmosphere itself and the myriad lives which exist in it are symbolical; they express, to the mind that can read them, the Thoughts of God "which the Demiurge hath written in the Worlds of Form."

But since man has the power to read and interpret the stupendous system of symbols which constitutes the objective Cosmos, he has also the power to rearrange natural objects, or to mould natural substances into new forms, and thus give them a new symbolical significance. This constitutes Artificial Symbolism in the strict sense.—The Shrine of Wisdom[29]

Why did Coburn go to England, and why, like Henry James and T. S. Eliot, did he remain, to become a British citizen in 1932? Perhaps, in 1900, it was as clear to Coburn that the photographers whose work he was later to bring together for exhibition in America—Hill and Adamson, Julia Margaret Cameron, Thomas Keith—were as much part of a great photographic tradition as it had been obvious to James that the great literary tradition of the nineteenth century was British. A simpler reason was that Fred Holland Day was utterly committed to English and Irish literature as bibliophile and as publisher of the poets of the Aesthetic and Decadent movements. Coburn believed that an artist could advance only by studying the best practitioners and that a number of admirations was essential at the start, but his objects of veneration differed from Day's: he was not so much obsessed with Oscar Wilde and Aubrey Beardsley as attracted to Whistler, Robert Louis Stevenson, and Lafcadio Hearn. Yet it was Day who probably gave him his literary orientation toward England and his interest in the mystery religions. The incense of learning wafted strong in the Day circle, and if this is where Coburn first took his steps toward adeptship in Rosicrucianism, perhaps it was Day's Visionist group that set him on the path to Freemasonry. To be a Rosicrucian it is first necessary to be a Christian and a Master Mason. Nobody as committed to Freemasonry as Coburn was from 1919 on could have seriously considered leaving the country that is its home. Coburn inserted himself into British life in this middle-class institution just as James did in the aristocracy of the country-house set and Eliot did in the upper middle class of the High Anglican Church.

The influence of the Symbolist movement on Coburn may be dated from the beginning of his lifelong admiration for Maurice Maeterlinck, who wrote on Ralph Waldo Emerson in the Boston magazine *Poet-Lore*.[30] Maeterlinck was admired on both sides of the Atlantic. In him converged the traditions of Oriental thought in writers from Emerson to William James and in the painters called the Nabis—Bonnard, Vuillard, and Maurice Denis. Many of Coburn's most important sitters for portraits were deeply influenced by Maeterlinck: Yeats, Symons, Harley

Granville Barker, Georg Brandes, Israel Zangwill, Max Beerbohm, Herbert French. It was French who produced Maeterlinck's most famous play, *The Blue-Bird*. Coburn did not manage to photograph Maeterlinck until 1915, when the dramatist had turned metaphysician, but Steichen photographed him in 1902 for the frontispiece of Maeterlinck's Neoplatonist book *The Buried Temple*, which proposed the study of the mystery religions as the noblest of all human activities. One of the bonds of friendship between Steichen and Coburn may have been Maeterlinck.

After Day and Maeterlinck, the three most important figures in Coburn's early life were Edward Carpenter, Arthur Symons, and Henry James. Like Day, these were sexually ambiguous figures who preferred what Plotinus called noncopulative love to a full heterosexual relationship. But if they were homosexual the expression of their feelings in no way took the mischievous form it did in Beardsley. On the contrary, Carpenter's expressed ideas on homosexuality took a high moral tone. Symons and Carpenter in particular considered the art of life more important even than the life of art, and they must have done much to help an immature Coburn in search of a father. When Perriton Maxwell, editor of *The Metropolitan*, gave him a list of London literati to make portraits of for the New York magazine, Coburn grasped the commercial opportunity but added luminaries of his own. The work that resulted was salable to *The Bookman* and *The Century*, but there is no doubt from the choice of subjects that the portraits were also consummations of Coburn's admirations. These were the Enlightened. In his *faux-naïf* way Coburn passed the activity off as lion hunting, but in fact he was assembling a personal pantheon of key figures in the modern fields of science and comparative religion.

The book that impressed Coburn most at twenty-five, a crucial time in his life, was Carpenter's *The Art of Creation* (1904), where we find a threefold division of the stages of human consciousness: the "simple consciousness" of the child or animal, demonic and only quasi divine, in which the instincts are followed without question; "self consciousness," half formed and

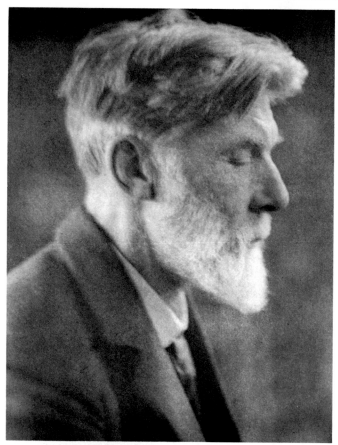

Robert Bridges, Chilswell, April 11th, 1913
(Plate **XXXII** from *Men of Mark*, 1913)

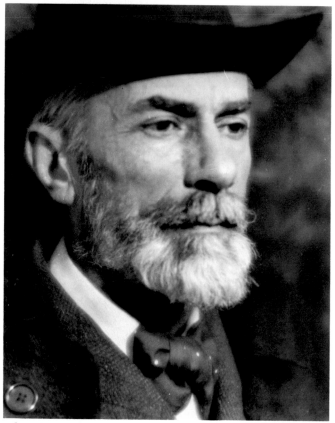

Edward Carpenter, 1905

transitional, which confuses knowledge with intellectual thought as if the latter was a form of true knowledge; and "cosmic consciousness" (the term used by R. M. Burcke, a friend of Walt Whitman's), which produces a stream of illuminated moments, or "illustrations," in which the mind knowing and the object known are identical. The cosmic state appears close to the child state but is now full of repose and truly divine. The second state is very disturbing, ego ridden, depressed, and terrified to the point of nervous breakdown. To progress to the third state was for Carpenter to undergo "the great Transformation."[31] Coburn's constant references to the childlike simplicity of his heroes was based on such an idea of the development of human consciousness.

Carpenter's book opened with an epigraph by Lao-tzu:

These two things, the spiritual and the material, though we call them by different names, in their Origin are one and the same.

Carpenter's metaphors for an ideal form of perception, which telescopes inner and outer, near and far, into one plane of consciousness, have photographic implications. To possess that kind of perception was "to be able to throw those mental images *direct* into the outer world so as to become visible and tangible to other, at once, and without intermediate operations." In Coburn's view, to recognize that kind of mental image in the sitter's face was the task of the photographer. To do so he saturated himself in the subject's books, "so that I might previously come to know something of the inner man." The inner man would be recognized at the release of the shutter. Like Thomas Eakins, Coburn preferred his subjects to be engaged in creative activity, even if only looking at a Chinese bowl. Best of all was playing music. Like Ansel Adams and Paul Caponigro, Coburn believed in the power of music to train the soul. He remembered the expression on Carpenter's face as the writer improvised on the piano the day Coburn visited him. Carpenter himself wrote:

. . . in moments of great feeling there flashes something out of people's faces and figures which is visible at once to those around, and which is intensely real, quite as real as a lightning flash, or memorable as a mass of rock.

This luminous moment was recognized by Coburn when he photographed Robert Bridges also improvising at the piano, or Yeats reading a poem. He was making the inner man visible.

The concept of recognition of something previously not known is at first difficult to understand. How can you recognize something you have never seen? Carpenter explained:

When an Idea that is struggling for expression within us meets with and recognizes the same Idea (itself indeed) expressed again in some outward form—be it man or woman, a flower, or slumbering ocean—there is an infinite sense of relief, of recognition, of rest, of *unity*; we are delivered from our little selves, our little desires and unrest; and with the eyes of the gods we see the gods.

Recognition was the discovery of a visual image of something already embedded in the mind. Coburn learned this view from

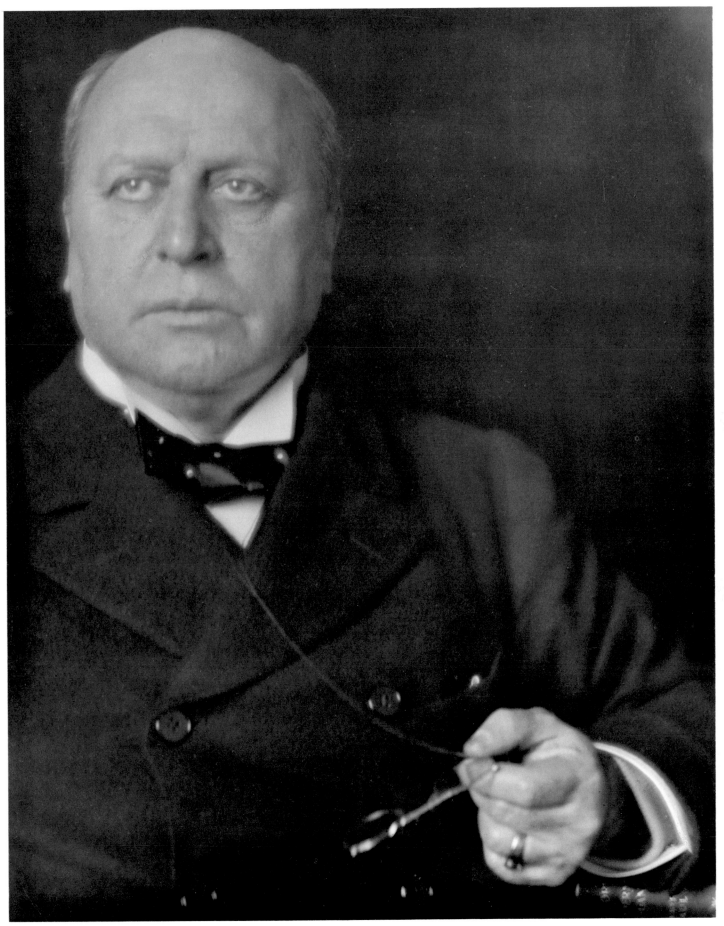

Henry James, 1906

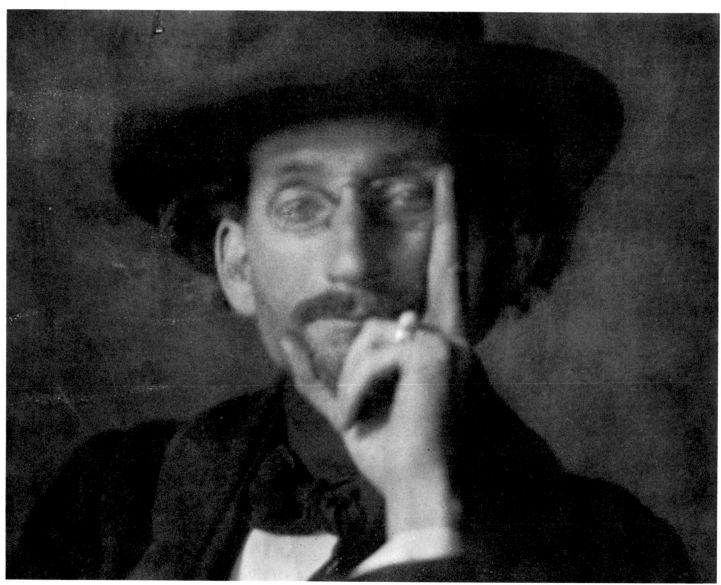

F. Holland Day, c. 1901

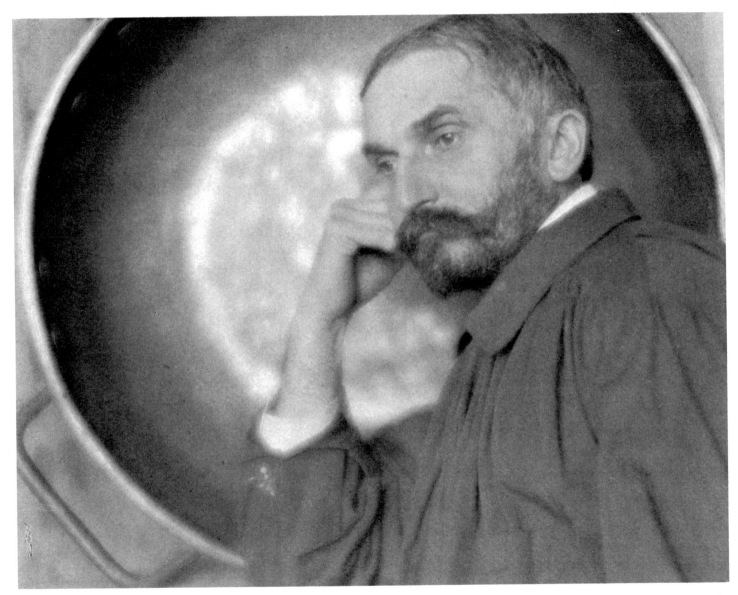

Arthur W. Dow, 1903

Carpenter and shared it with Arthur Symons and Henry James. It was the cornerstone of the third order of consciousness, which was also the symbolist stage. Carpenter wrote:

> When this consciousness comes it brings with it a strange illumination. For the object and the ego are felt to be one, not only through the special act of knowledge which unites them, but deep down in their very essence. A circle is, as it were, completed; and the external act of knowledge is no longer merely external, but is transformed into a symbol of a vast underlying life.

To be an artist was to find a way to denote this consciousness by examples drawn from external reality.

Maeterlinck had been praised for blending study of the ant and bee in a movement from the finite to the infinite, and Carpenter made a similar study of the mayfly. The influences of Carpenter, Maeterlinck, and even Henry James came together in Coburn's work when he illustrated Maeterlinck's *The Intelligence of the Flowers* (1907). As well as illustrating flowers, Coburn offered two pictures from his *Moor Park* series. He had been introduced by Lady Ebury, the owner of Moor Park, by James, who had an affection for this great house because of a romantic connection. So the image of deer and trees that appears in the book *Moor Park* (1915) may have been made in response to Coburn's interest in Maeterlinck and Carpenter as early as 1906. Coburn recognized this image as being of something already embedded in his own mind. It embodied the image-making faculty or formative ideal in terms of deer and trees, which Carpenter had specifically mentioned:

> In the vast succession of individuals, of generations, the total mass of accumulated thought and ingenuity had built itself and *embodied itself* in the marvellous expressiveness, and meaning of the stag or tree.

Deer and trees share a universal order in creation even though they are very different in appearance. The picture expresses this in concrete terms: from the left, two deer match two trees, one deer one tree, two deer two trees, in a rhyming pattern that is not pursued systematically but is sufficiently suggestive to make the connection between them.

The relation between the spiritual and the physical, by which physical things in the world are seen to be endowed with larger, infinitely interpretable meanings, is the basis of Symbolist correspondence theory, which can, of course, lead eventually to excessive allegorization. Charles H. Caffin, one of Coburn's earliest critics, wrote about the difference between symbolism and allegory in *Camera Work* in 1907. The difference was between a core of meaning that could not be expressed except by means of a sign or token and a coded message that restated a known idea. Caffin wrote:

> Yet, if there were nothing but this clear distinction between the ideas conveyed by these words, there would not be the confusion in their usage. As a matter of fact, they overlap; allegory using symbolism, and the latter often basing itself on the mind's natural tendency toward allegorical representation.[32]

Self-portrait, c. 1905

28

The true characteristic of Symbolism for Caffin was its subtlety and ineffability, its capacity to evoke the limitlessness of spirit. One test for symbolism in art is to decide whether the work in question was abstractly conceived or impressionistically evolved. In allegory the work is static, emotion repressed to achieve intellectual intensity; in symbolism the work is deliberately evanescent, so much so that it begins to be difficult to attach the intensity of emotion to a particular object in the visible world. If allegory is exaggerated in its desire to convey ideas, symbolism is always in danger of not conveying precise ideas at all. But both these modes of ideal expression have little to do with realism in art, the faithful, detailed description of nature.

The technical means that Coburn used to achieve nonrealistic effects expressive of an ideal vision were soft-focus lenses and platinum printing to produce clarity without sharpness and softness without fuzziness. Sadakichi Hartmann praised Whistler's addition to the Japanese method of composition of something that no Japanese prints suggested—"light, atmosphere, distance, and mystery."[33] Aerial or atmospheric perspective was one basis of Impressionist practice. When Coburn used it he did not unthinkingly take up a vogue but adopted a means of expression derived from a tradition in British photography that ran from Hill and Adamson to Julia Margaret Cameron to P. H. Emerson and George Davison. Fred Holland Day was following this tradition when he introduced Coburn in 1901 to a British soft-focus lens, probably the Dallmeyer-Bergheim of 1896, duplicated by the Boston firm of Pinkham & Smith, which had offices in the street where Coburn lived. It is as significant that Day, Coburn, Steichen, and Clarence White availed themselves of this soft-focus lens as that they used the platinum printing process. Caffin saw Coburn, Steichen, and Frank Eugene as members of the painter-etcher wing of the New American Photography and aberrant from the straight path advocated by Alfred Stieglitz.[34] Coburn confirmed it in an interview when he referred to Steichen, Eugene, and himself as "the Whistlers of photography":

> What I try to do is see the little piece that matters in the midst of nature's massiveness, and (by dint of focal adjustment and so forth) concentrate the interest on that. That done, I use every inch of my knowledge to retain the purely photographic qualities. Of course, by "photographic qualities" I don't mean hard pure lens work. I don't mean the sharp shrewish acidity of your ordinary cabinet photograph. I mean photographic in the sense that Whistler was photographic (it's a pity, by the way, that he didn't live long enough to use a camera, it would have saved him so much time) and that Leader isn't.[35]

To claim that Whistler was "photographic" and that Benjamin Williams Leader (1831–1923), the English landscape painter, was not asserted that photography shared with Impressionist painting its concern with rendering diffused light. At one stage Coburn was using a lens that he unscrewed in the mount so it would work more like a Smith lens, of which he had in the course of time at least a dozen, of various focal lengths. What he liked about the Smith lenses was that they produced atmosphere or breadth of effect:

> When the history of Artistic Photography comes to be written, the question of diffusion will assume its real importance, and the Smith Lens will receive the recognition it so fully deserves, for one of the things that makes photography worth while as a means of personal expression, is Lens Quality. Back in the dark ages, it seems to me I gave some considerable thought to this question of diffusion. I used a battery of various size pin holes, which were excellent, but for their excessive slowness. I enlarged through bolting silk, and printed from the reversed negative, but all these were make-shift methods at best. I well remember hailing with joy the news imparted to me by F. Holland Day, that in Boston, Mass,. U.S.A. (my native town), there was an optician by the name of Smith who had a theory, and was working on this very problem of diffusion, and was making lenses for photographic purposes only for the pleasure it gave him to produce something different than others made, and I am the proud possessor of one of the earliest he turned out. After making half a dozen exposures with this lens, I saw that it was exactly what I desired. It was a single combination lens, fifteen inches in focus, that gave a quality of image that I had dreamed of, but never believed that I would be able to get. To any one using a lens of this type for the first time, after using a fully corrected anastigmat, he will find much difficulty in deciding what is the exact focus. There will seem to be a belt of focus, more than an actual plane of definite sharpness, and such is really the case, for the Semi-Achromatic Lens has a great depth of apparent focus, but none actual. You have no more of what Bernard Shaw calls one of "the infuriating academicisms of photography," one plane of the picture sharp and all the others woolly and unnatural, a thing that no self-respecting human eye would ever see. The Semi-Achromatic here seems in some extraordinary way, to break up this plane of sharpness and distribute it over the entire depth of the image. It gives to the distance in landscapes the shimmering quality of sunlight seen through a summer mist.[36]

The remark about what the self-respecting human eye would see or not see is an allusion to the controversy about Naturalism that preoccupied the best photographers of the eighties and nineties. P. H. Emerson's theory of differential focus still left room for improvement so far as Coburn was concerned. The belt of focus created a depth and breadth of effect that idealized the whole picture, whereas the Naturalists in photography were still concerned with maintaining a sharp contact with reality in at least one plane. They wished to remain faithful to the finite; Coburn wanted to approach the infinite.

The question of color in photography briefly interested Coburn in 1907. The invention of the Autochrome by Lumière in Paris that year drew Stieglitz and Steichen there to investigate its possibilities. In September 1907 Coburn went to Paris to see Stieglitz and Steichen, and Steichen instructed him in its use. Steichen also introduced Shaw, R. Child Bayley, and George Davison to the process in England. By December 1907 Coburn was busy collecting examples for the special *Studio* summer number, *Colour Photography* (1908). He did not obtain examples from Steichen and Stieglitz, which must have given them

offense, but work by Heinrich Kühn, Frank Eugene, Shaw, Baron de Meyer, and Coburn himself was reproduced. There is no doubt that Coburn was responsible for the selection. "I am only asking the very best people to contribute."[37]

When the book appeared it contained a fine introduction by Dixon Scott, the London correspondent of *The Liverpool Courier*, who had also interviewed Coburn on the subject of color photography. He criticized Shaw's contribution in terms that Coburn had used to attack the cabinet photograph. It possessed "a sharpened and acidulous nature, a nature curiously tense and glittering, almost metallic."[38] He criticized Kühn's contribution, "a picture which has been suddenly robbed of all those delicate nerves and tendons of pervasive colour-chords, the sly echoes and running threads, which the painter uses to pull his work into one mounting accordance." The color picture was too sharp and lacked overall coherence. The question was whether this was a temporary state of affairs in the art or irredeemable. Scott described the Autochrome process:

> Starch grains coloured green, starch-grains coloured violet, and starch-grains coloured orange (green, violet and orange being, of course, the three prime colours) are equally enmingled, so that they seem to form a uniform grey dust, and are then densely and adroitly marshalled, some four millions to the square inch, on the surface of a single plate; and it is over this fabulous army that the sensitive film of panchromatic emulsion, the chemical prism which captures the image, is delicately outstretched. The result of this elaborate and perfect ambush is a complete surrender on the part of the colour-rays.

The problem, so far as Scott was concerned, was that the aesthetic effect was as automatic as the technical effect. There was no room for any kind of manipulation of the image in the printing stage. Fanatical accuracy produced an unnatural acidity and asperity:

> We all know that when we survey a landscape we do not see each colour independently, at its intrinsic value, but that all sorts of strange feuds and alliances going on between the colours as they settle themselves in the chamber of the eye result in an image curiously interwoven and interdependent— this colour being subordinated to that, another thrilling warmly in reponse to the attentions of a fourth, a fifth and sixth entering darkly into a sinister suicidal pact.

The Autochrome, however, did not behave like the eye but registered hard blocks of color. Dixon thought it would be almost impossible to find in nature subjects where possibilities for harmonious composition and harmonious color existed in the same spot. The painter knew better than to expect that and arranged things accordingly. The photographer had to stage his subjects if he wanted similar success in color photography. Coburn made portraits of ladies in dresses of flat orange and blue and photographed the Freer collection of Whistlers and Oriental porcelain in Detroit. He did not consider himself a manipulator like Robert Demachy but a relatively straight photographer. But when we compare the example in *Colour Photography* of Frank Eugene's very straight portrait of two sisters with still-life elements with Coburn's "Autumn Landscape" it is clear that Coburn was attempting a well-spaced, well-diffused landscape, even if not quite achieving an evenly distributed softness over the whole picture. Complete control over the printing of the reproduction from the transparency might have enabled him to achieve even that. A. J. Anderson had recommended the Impressionist approach:

> If a little more attention were paid to the paintings of Monet and Le Sidaner, which are examples of science applied by artists to pictorial ends, colour photography might make some real progress.[39]

Monet's Impressionist London achieved effects of mass by avoiding hard outlines. The masters of Ukiyo-e gave their printers the opportunity to use graduated though firmly blocked color. Coburn saw the nonnaturalistic possibilities of graduated blocks of color in the Autochrome process but, unable to manipulate them, produced a kind of color-block arrangement of flat tones.

Coburn wanted to take accidental aspects of nature and so organize them as to achieve a suggestion of inner harmony that was not merely sensuous but also spiritual. He wanted to combine the ability of the telephoto lens to achieve spatial simplification with that of the Smith lens to achieve luminous simplification. It was inevitable that such a generalization of subjects would produce a number of isolated pictorial motifs or symbols. An apparently accidental method of rendering them according to Impressionist principles was used together with a Japanese method of rendering the essential nature of things in terms of psychic geometry to such a degree that the actual and the ideal, the sensible and the intelligible, were reconciled. To eliminate the insignificant by distilling transient effects into formal elements, to idealize without losing a sense of the particular, to simplify by employing spellbinding geometrical forms, and to produce from the relation between the subjective and the objective a spiritual quality—this was the goal of Symbolism in photography as Coburn understood it. Arthur Symons wrote in an essay on Maeterlinck:

> All art hates the vague—not the mysterious, but the vague; two opposites very commonly confused, as the secret with the obscure, the infinite with the indefinite. And the artist who is a mystic hates the vague with a more profound hatred than any other artist.[40]

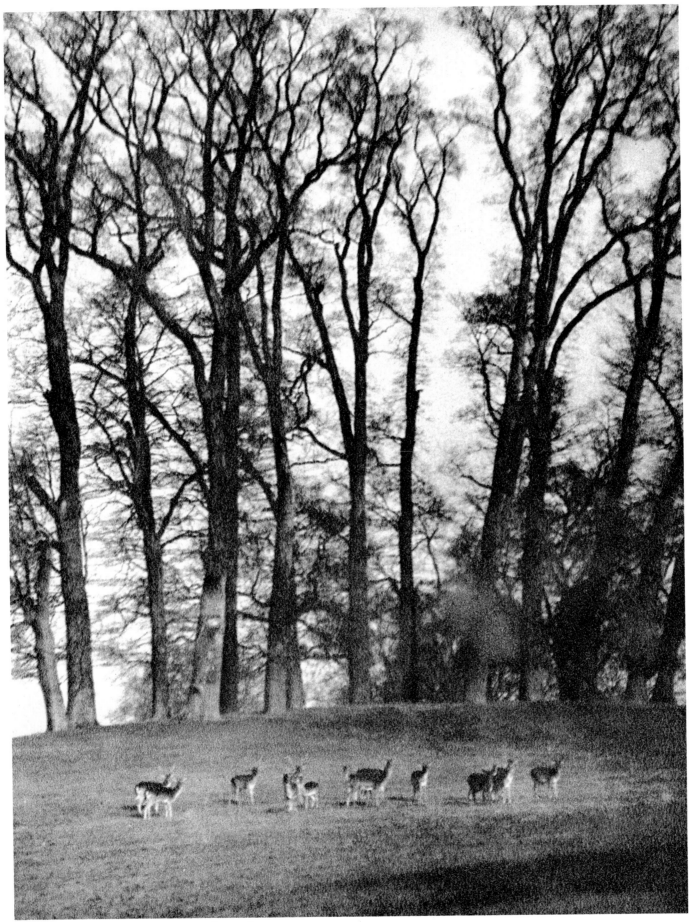

Deer, 1906 (Plate XVI from *Moor Park*, 1915)

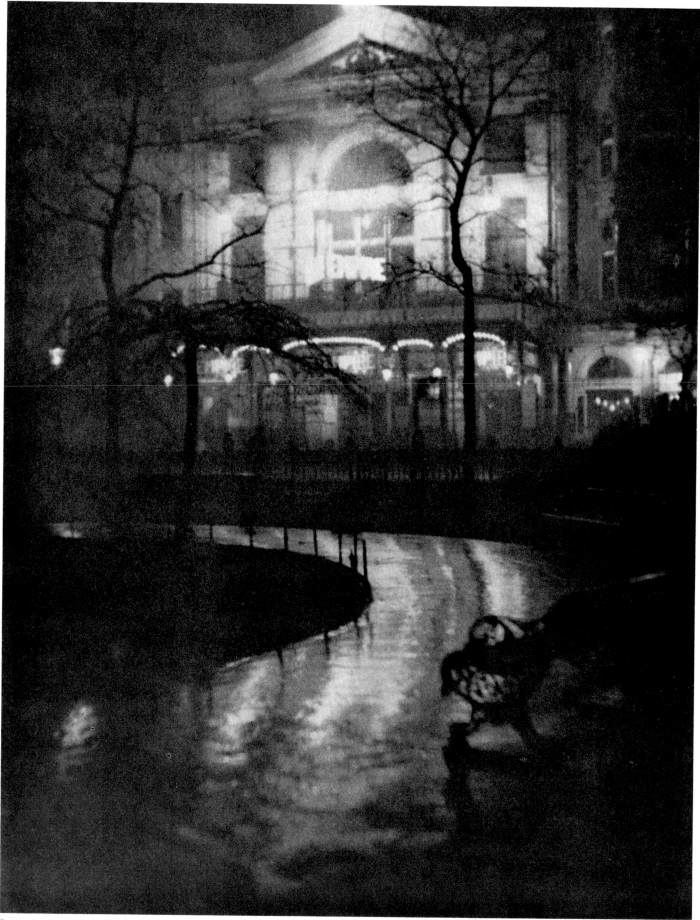

Leicester Square, 1906 (Plate XI from *London*, 1909)

Who has not stood on a street corner on a grey October evening, when the sudden opening of a cloud has bathed a familiar scene with an unwonted magic as the sun painted it with flames of gold? Those who look upon such a pageant and are glad are artists in their hearts. It is for the camera to make them so in very fact.—Alvin Langdon Coburn[41]

In 1888 Joseph Pennell, an American illustrator who later lived in London, and who opposed the spread of photography into his preserve, illustrated an essay on London by Henry James for *The Century*.[42] A vogue of illustrating the great cities of the world followed in the next two decades. In 1892 *Great Streets of the World* was published, for which Andrew Lang wrote on Piccadilly and Henry James on the Grand Canal in Venice. Pennell was to have collaborated on a book on London with James in 1900, but the great number of charcoal drawings he made did not appear until 1924, when Sidney Dark wrote a book on London around them. Pennell expected to illustrate James's *The American Scene*, but this project also failed. But the etchings for it did appear in *The Century* in 1905[43] and included many of the New York subjects that Coburn and Stieglitz photographed later. They set a fashion for issuing such illustrations without a text and offered some competition to the photographers. On the whole Pennell despised the taste of the authors whom he illustrated. To him illustration usually meant explaining what the writer had failed to make clear. To Coburn, however, it meant a kind of indirect elucidation, not competing with the text but typifying or idealizing it at one remove. James did not want the kind of realistic description that Pennell offered. Instead of actual places and objects James required types and archetypes. The illustrator had to recognize in nature and society what already existed in the author's mind and make an ideal representation of it.

Henry James's father was a prominent Swedenborgian, and his brother, William James, the philosopher, was the author of *The Varieties of Religious Experience* (1902). Like Coburn, Henry James was familiar with the New England tradition of comparative religious thought. When, in 1906, he asked Coburn to provide frontispieces for the New York edition of his collected novels he gave the young man specific instructions in person and by letter in which such words as "recognition," "transfiguration," and "presentment" occurred.[44] A "recognition" amounted to a Gnostic recollection, a door of ancient memory being opened. "Transfiguration" meant obtaining the correct angle of view, preferably oblique, to achieve an idealized image. A "presentment" suggested the strangeness of an image rising in the mind like a latent image coming up on the printing paper. James sought "images always confessing themselves mere optical symbols or echoes, expressions of no particular thing in the text,

but only of this or that thing."[45] He wanted empty stage sets, the actors invisible but implied, a kind of static theater like Maeterlinck's. In most cases James gave Coburn an idea of the type of image he wanted and sent him to particular streets where he would find the picture that embodied it.

> Once you've got the Type into your head, you will easily recognise specimens by walking in the old residential and "noble" parts of the city.

A Type, capitalized, is a model or pattern. It is the general aspect of a thing, not its particularity. It is universal in that it considers the part as a whole. James wrote to Coburn:

> I yearn for some aspect of the Théâtre Français for possible use in *The Tragic Muse*, by something of course of the same transfigured nature; some ingeniously hit-upon angle or presentment of its rather majestic big square mass and classic colonnade.

An "aspect" meant not the way the natural scene strikes the mind but the way it is actively looked at. The word usually signifies outward appearance, but what James demanded was ideal representation. His encouragement of Coburn to make substantial, even monumental, images can be detected in some of the Edinburgh and Moor Park photographs Coburn made in the period of James's tutelage.

Yet James also wrote in appreciation of superficial aspects of London:

> . . . the atmosphere, with its magnificent mystifications, which flatters and superfuses, makes everything brown, rich, dim, vague, magnifies distances and minimises details, confirms the inference of vastness by suggesting that, as the great city makes everything, it makes its own system of weather and its own optical laws.[46]

Here he was expressing a point of view close to that of Arthur Symons.

It was Symons, the author of *The Symbolist Movement in Literature* (1899), whose *Cities* (1903) provided the model for Coburn's own projected series, *The Adventures of Cities*, on London, Birmingham, Liverpool, Edinburgh, Paris, Pittsburgh, New York, and Boston. Symons thought that cities had characters like people and that profound imaginative insight was need-

ed to appreciate them. The appearance of a city was different from its essence. To draw confidences out of the stones one had to put oneself into them, the vision rising up toward one like the presentment of the print. This was the Symbolist method—to make sense of the world by subjective means. In 1906 Coburn and Symons planned a collaboration, *London: A Book of Aspects*, but failed to agree on a publisher, and in 1909 a book of that title appeared with Symons's text but without Coburn's photographs. These appeared separately in Coburn's portfolio of London the same year.

In 1914 two copies of *London: A Book of Aspects* as it was originally conceived were produced with a specially printed title page and a beautiful binding. One copy was for the publisher of Symons's book, Edmund D. Brooks of Minneapolis, and one for Coburn. Examination of Coburn's copy shows how misleading an existence his 1909 *London* portfolio has had without Symons's text.[47] Coburn said later[48] that he took Symons to Hungerford and induced him to write the following Whistlerian reverie:

> The river seems to have suddenly become a lake; under the black arches of Waterloo Bridge there are reflections of golden fire, multiplying arch beyond arch, in a lovely tangle. The Surrey side is dark, with tall vague buildings rising out of the mud on which a little water crawls: is it the water that moves or the shadows? A few empty barges or steamers lie in solid patches on the water near the bank; and a stationary sky-sign, hideous where it defaces the night, turns in the water to wavering bars of rosy orange. The buildings on the Embankment rise up, walls of soft greyness with squares of lighted windows, which make patterns across them. They tremble in the mist, their shapes flicker; it seems as if a breath would blow out their lights and leave them bodiless husks in the wind. From one of the tallest chimneys a reddish smoke floats and twists like a flag.[49]

But he did not confess that his photograph "The Embankment" was a response to Symons's text:

> Below, the Embankment curves towards Cleopatra's needle: you see the curve of the wall, as the lamps light it, leaving the obelisk in shadow, and falling faintly on the grey mud in the river. Just that corner has a mysterious air, as if secluded, in the heart of a pageant; I know not what makes it quite so tragic and melancholy. The aspect of the night, the aspect of London, pricked out in points of fire against an enveloping darkness, is as beautiful as any sunset or any mountain; I do not know any more beautiful aspect.

Like James, Symons thought it was atmosphere that made the picture, and he was equally enamored of mist and smoke:

> English air, working upon London smoke, creates the real London. The real London is not a city of uniform brightness, like Paris, nor of savage gloom, like Prague; it is a picture continually changing, a continual sequence of pictures, and there is no knowing what mean street corner may not suddenly take on a glory not its own. The English mist is always at work like a subtle painter, and London is a vast canvas prepared for the mist to work on. The especial beauty of London is the Thames, and the Thames is so wonderful because the mist is always changing its shapes and colours, always making its lights mysterious, and building palaces of cloud out of mere Parliament houses with their jags and turrets. When the mist collaborates with night and rain, the masterpiece is created.

Night was what Symons prescribed for the streets where the theater crowds come out:

> The Circus is like a whirlpool, streams pour steadily outward from the centre, where the fountain stands for a symbol. The lights glitter outside theatres and music-halls and restaurants; lights coruscate, flash from the walls, dart from the vehicles; a dark tangle of roofs and horses knots itself together and swiftly separates at every moment; all the pavements are aswarm with people hurrying.

And night was needed to render working-class Edgware Road:

> . . . naphtha flames burn over every stall, flaring away from the wind, and lighting up the faces that lean towards them from the crowd on the pavement.[50]

But for Symons the choicest place in London was the Temple, in particular Fountain Court, where he lived:

> There is a moment when you are in Fleet Street . . . with the continual rumble of wheels in the road, the swaying heights of omnibuses beside you, distracting your eyes, the dust, clatter, confusion, heat, bewilderment of that thoroughfare; and suddenly you go under a low doorway, where large wooden doors and a smaller side-door stand open, and you are suddenly in quiet. . . .
>
> I had the top flat in what is really the back of one of the old houses in Essex Street, taken into the Temple; it had a stone balcony from which I looked down on a wide open court, with a stone fountain in the middle, broad rows of stone steps leading upward and downward, with a splendid effect of decoration; in one corner of the court was Middle Temple Hall, where a play of Shakespeare's was acted while Shakespeare was alive; all around were the backs of old buildings, and there were old trees, under which there was a bench in summer, and there was the glimpse of gardens going down to the Embankment.
>
> The nights in Fountain Court were a continual delight to me. I lived then chiefly by night, and when I came in late I used often to sit on the bench under the trees, where no one else ever sat at those hours. I sat there, looking at the silent water in the basin of the fountain, and at the leaves overhead, and at the sky through the leaves. . . .

"Fountain Court" is perhaps Coburn's finest picture. The elevated and oblique angle from the apartment where Symons had lived produced a latent triangle of hidden pathways and transformed the basin into an ellipse with the oval of the fountain placed eccentrically within it. The woman is as still as the fountain. Maeterlinck would have recognized this relationship as allegorical. Fenollosa would have sensed the Taoism of the implied circle and triangles. But the picture does not propose itself schematically as an emblem. It has, in fact, the appearance of

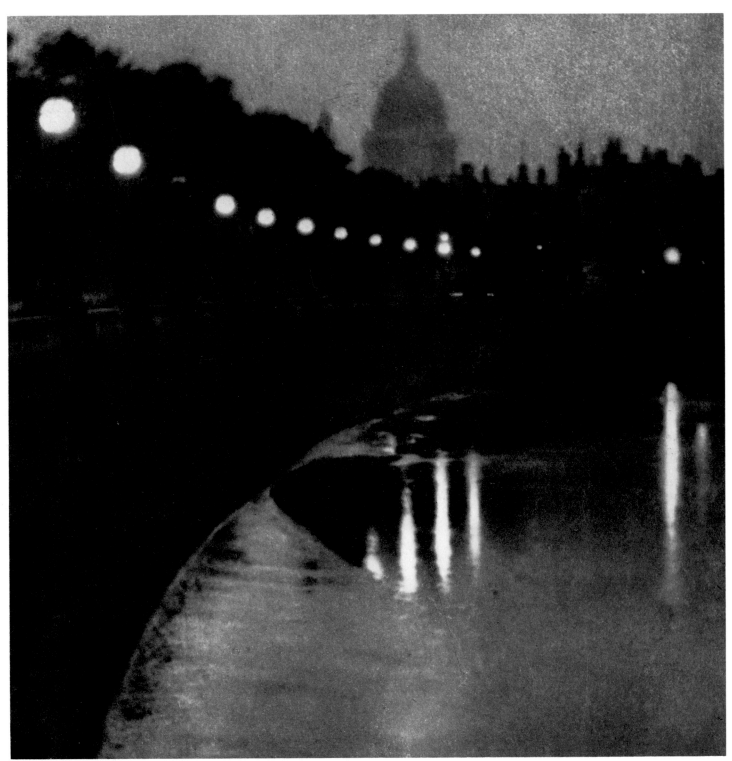

The Embankment, London, 1906 (Plate from *The Door in the Wall,* 1911)

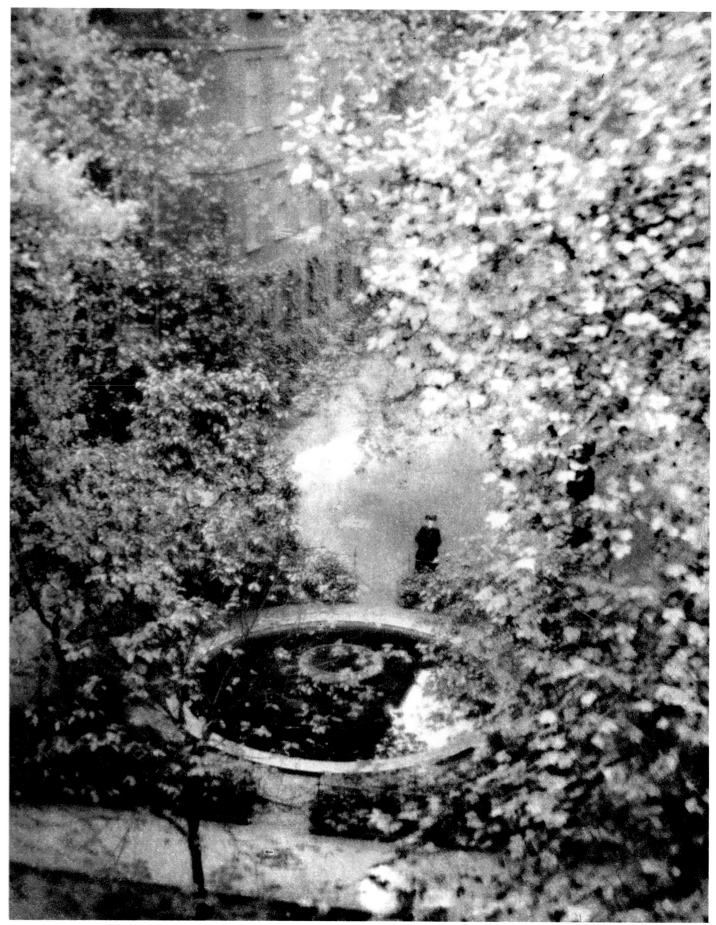

Fountain Court, 1906 (Plate II from *London*, 1909)

the accidental and the lyrical. Yet it contains all Plotinus's categories of the ideal. It is a meditation on sameness and difference, permanence and change, and the nature of the spiritual life. The proof of its intentionality is implicit in the parody Coburn made of it in a picture of a man, dressed like an Eastern sage and with a wand in his hand, standing on the fountain beneath an Italian pergola posing as a Japanese garden roof. The subject of this picture is the great Western humorist Mark Twain, who was also interested in the occult but could share a parodic joke on the subject with Coburn.

When Henry James received a copy of Coburn's *London* book he expressed certain reservations about "Paddington Canal" and "Regents Canal" (See: Frontispiece). He thought them suburban and out of place in a work otherwise celebrating the monumental aspect of London.[51] He was unaware that these were intended as illustrations. Symons wrote:

> The canals, in London, have a mysterious quality, made up of sordid and beautiful elements, now a black trail, horrible, crawling secretly; now a sudden opening, as at Maida Vale, between dull houses, upon the sky. At twilight in winter the canal smokes and flares, a long line of water with its double row of lamps, dividing the land. From where Browning lived for so many years, there is an aspect which might well have reminded him of Venice. The canal parts, and goes two ways, broadening to almost a lagoon, where trees droop over the water from a kind of island, with rocky houses perched on it. You see the curve of a bridge, formed by the shadow into a pure circle, and lighted by the reflection of a gas-lamp in the water beyond; and the dim road opposite following the line of the canal, might be a calle; only the long hull of a barge lying there is not Venetian in shape, and decidedly, the atmosphere is not Venetian. . . . The barges crawl past with inexpressible slowness; coming out slowly after the horse and the rope from under the bridge, with a woman leaning motionless against the helm, and drifting on as if they were not moving at all.

In "Regents Canal" the collaboration worked well for Symons and Coburn. Symons associated the canal with Browning and Verlaine; it was squalidly charming. Coburn, however, took a Japanese bridge by Monet and—knowing that a bridge without figures is inconceivable in Japanese art and that in Sesshū's tradition they must be types rather than persons—rendered the figures as silhouettes. The great wedge of light, an arrow of bright water that projects itself into the bottom of the frame in a kind of reverse perspective, matches the torque on the right side of the bridge in the dynamic organization of the picture plane. Yet this Japanese design remains a redolent part of the Western industrial world.

The light of winter afternoons suffuses many of Coburn's pictures. Schooled by Symons to view cities in terms of light, he wrote about New York in words that Symons might have used:

> . . . it is only at twilight that the city reveals itself to me in the fulness of its beauty, when the arc lights on the Avenue click into being. Many an evening I have watched them and studied just which ones appeared first and why. They begin somewhere about Twenty-sixth street, where it is darkest,

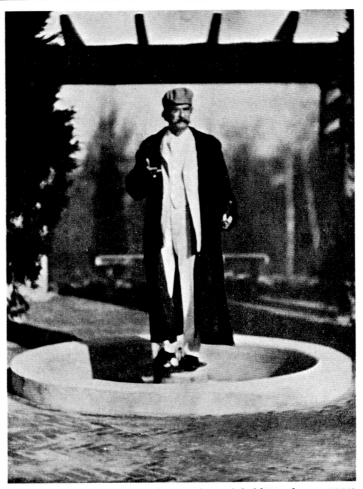

Mark Twain, 1908 (From *Mark Twain* by Archibald Henderson, 1911)

and gradually the great white globes glow one by one, up past the Waldorf and the new Library, like the stringing of pearls, until they burst out into a diamond pendant at the group of hotels at Fifty-ninth street.

> Probably there is a man at a switchboard somewhere, but the effect is like destiny, and regularly each night, like the stars, we have the lighting up of the Avenue.[52]

The Impressionist emphasis on the atmospheric treatment of the city was, however, not enough for Coburn. The effect may be ephemeral, but it is nevertheless like destiny, in the stars. The man at the switchboard acts in a double sense—at the behest of the lighting company but also in accordance with the predetermining agency of God. Symons wrote:

> If only we had a Walt Whitman for London! Whitman is one of the voices of the earth, and it is only in Whitman that the paving-stones really speak, with a voice as authentic as the voice of the hills. He knew no distinction between what is called the work of nature and what is the work of men.

Coburn wrote about New York in just the same spirit:

> As I steamed up New York harbor the other day on the liner that brought me home from abroad I felt the kinship of the mind that could produce those magnificent Martian-like monsters, the suspension bridges, with that of the photogra-

SKYSCRAPERS OF NEW YORK

THE CAÑON WILLIAM STREET

SHOWN IN A GROUP OF NEW ETCHINGS BY JOSEPH PENNELL

Joseph Pennell, *The Cañon, William Street* (From
"Skyscrapers of New York," a group of six etchings by
Pennell in *The Century* magazine, volume 69, March 1905)

pher of the new School. The one uses his brain to fashion a thing of steel girders, a spider's web of beauty to glisten in the sun, the other blends chemistry and optics with personality in such a way as to produce a lasting impression of a beautiful fragment of nature. The work of both, the bridge-builder and the photographer, owes its existence to man's conquest over nature.[53]

The confidence of Coburn's generation in municipal life was supreme. At this period of its history New York was booming financially, industrially, and architecturally, and it continued to do so until the early twenties. Paul Strand and Charles Sheeler's film *Manhatta*, with a title drawn from Whitman, had been called at its first screenings in 1920 *New York the Magnificent*. Max Weber, the Secessionist painter, who hung the epoch-making International Exhibition of Pictorial Photography in Buffalo in 1910, claimed that it was he who put pressure on Stieglitz to make the image called "The City of Ambition,"[54] the title appearing to have been quite unironic—not until 1923 would Stieglitz offer a harnessed gelding as an emblem in "Spiritual America." Stieglitz and Coburn photographed New York in very similar ways, and it is likely that Weber, who renouned his allegiance to Stieglitz only in 1911, was an influence on both.

Coburn's response to New York was rapid and excited:

Just imagine any one trying to paint at the corner of Thirty-fourth street where Broadway and Sixth avenue cross! The camera has recorded an impression in the flashing fragment of a second. But what about the training, you will say, that has made this seizing of the momentary vision possible? It is, let me tell you, no easy thing to acquire, and necessitates years of practice and something of the instinctive quality that makes a good marksman. Just think of the combination of knowledge and sureness of vision that was required to make possible Stieglitz's "Winter on Fifth Avenue." If you call it a "glorified snapshot" you must remember that life has much of this same quality. We are comets across the sky of eternity.

It has been said of me, to come to the personal aspect of this problem, that I work too quickly, and that I attempt to photograph all New York in a week. Now to me New York is a vision that rises out of the sea as I come up the harbor on my Atlantic liner, and which glimmers for a while in the sun for the first of my stay amidst its pinnacles; but which vanishes, but for fragmentary glimpses, as I become one of the grey creatures that crawl about like ants at the bottom of its gloomy caverns. My apparently unseemly hurry has for its object my burning desire to record, translate, create, if you like, these visions of mine before they fade. I can do only the creative part of photography, the making of the negative, with the fire of enthusiasm burning at the white heat; but the final stage, the print, requires quiet contemplation, time, in fact, for its fullest expression. That is why my best work is from American negatives printed in England.[55]

The relation expressed is not only between fleeting time and universal art but between the life of man and his destiny. A glorified snapshot can be at the hands of an artist a snapshot glorified—made in time but eternally exalted.

The wonders of work were paralleled by the wonders of na-

The Stock Exchange, 1909 (Plate XVII from *New York,* 1910)

The Tunnel Builders, 1909 (Plate XII from *New York*, 1910)

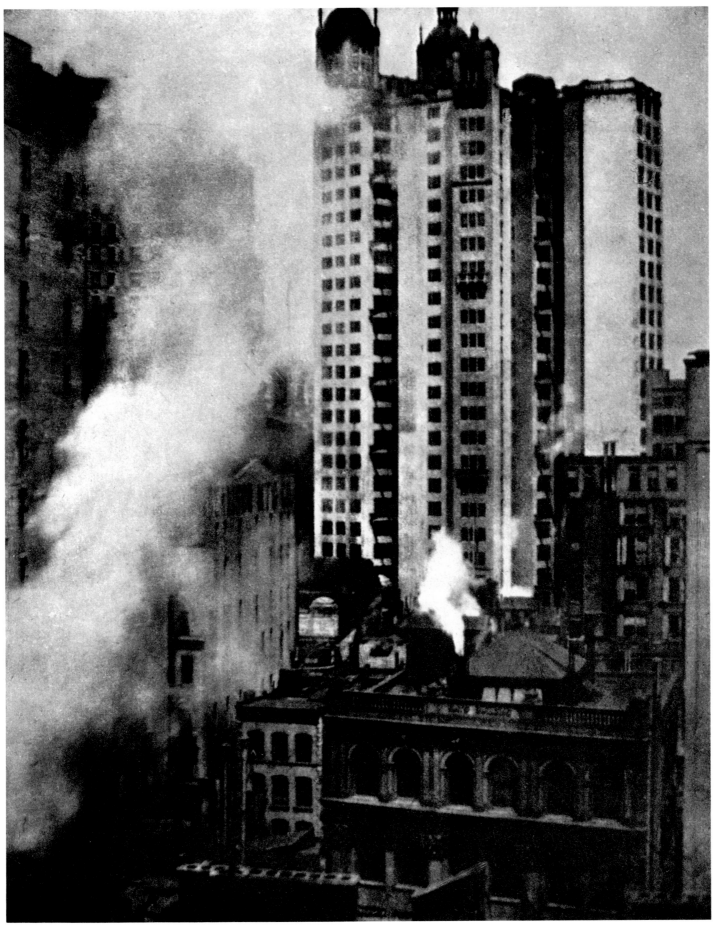

The Park Row Building, 1909 (Plate XX from *New York,* 1910)

ture. A great quarry was like a canyon, and a canyon was like a street of skyscrapers. The works of God and man were analogous. John C. Van Dyke, who wrote *The New New York* (1909), went on quite naturally to write *The Grand Canyon of the Colorado* (1920). When Coburn went to the Grand Canyon in 1911 it so impressed him with its height that he returned to New York in 1912 to photograph the city this time from its topmost pinnacles. By coincidence, when Dow and Coburn were at the canyon and in Yosemite, Joseph Pennell was there also. At the time he made his beautiful etchings *Skyscrapers of New York* (1905), this rival of photographers actually had a studio at 291 Fifth Avenue on the same floor as Stieglitz. Pennell saw himself in a realistic tradition of painting and etching that included Alden Weir's New York at night, George Bellows's docks, Childe Hassam's high buildings, and Thornton Oakley's coal breakers, but he claimed surprising priority for the modern rendering of the theme of the wonder of work for his beloved Whistler:

> What are the Thames etchings, "Wapping," "The Last of Old Westminster," "The Nocturnes"—but records of work?

He hinted darkly at Stieglitz's and Coburn's photographic invasion of this territory:

> There are others, too, who have seen the opportunity to prig and steal—but this is evident, just as it is evident that they will give up painting and drawing work for the next new thing.[56]

Although Coburn never mentioned Pennell he must have known of him. Pennell had, after all, illustrated several of James's travel books, including *A Little Tour in France*, *Italian Hours*, and *English Hours*. Furthermore, Pennell was a great admirer of the British painter-etcher Frank Brangwyn, with whom Coburn had studied. Having described a tradition of industrial and municipal graphic art in America, Pennell proceeded to bracket Brangwyn with Constantin Meunier, the Belgian painter of the Borinage, as worthy European counterparts. When Coburn was at his small school in London, Brangwyn was working on the murals for the British Room at the Venice Biennial of 1905. The panels had as subjects blacksmiths, steelworkers, potters, and excavators. Etching on zinc, without preparatory drawings, Brangwyn also treated such subjects as sawyers, barge builders, men on lighters, and workers in tarpits and on scaffolding.[57] The workaday age of modern commerce and industrial beauty was the theme that made him an international figure by 1907. But just as Coburn's photographs of the Black Country (the industrial region of Staffordshire and Warwickshire), of tunnelers, spinners, and foundry workers, and of barges in Rotterdam and ships in Liverpool originated in Brangwyn, so his work in New York and Pittsburgh owed a great deal to Pennell.

Coburn's sensibility was formed in part by writers and artists like Shaw, Carpenter, and Brangwyn who had direct links with socialism. He had delighted in Carpenter's Whitmanian poems *Towards Democracy* (1902) and was to become the close friend of the photographer George Davison, whose later life, like Ruskin's and Morris's before him, was given over to socialist agitation and organization. But unlike Brangwyn, who used human figures to structure his pictures of work, Coburn in the (*London*)

and (*New York*) portfolios simply included them as silhouettes. Amber Reeves, Coburn's cousin and H.G. Wells's mistress, who wrote an excellent essay on Coburn's work in 1909, probably with his help, claimed that a distinction could be made between the New York and London pictures with regard to the relation of machinery to men:

> All through the London pictures there are implied the men who made and use the things, but in the pictures of New York the sheer brute thing has become so untrammelled and so triumphant that it dwarfs its creator.[58]

Pennell too was more impressed with the grandeur and power of the American scene than with its human implications: Pittsburgh, the work city of the world; Minneapolis, with mills as admirable as the cathedrals of France; and New York, the temple of commerce. His appreciation of steel plants, coal fields, bridges, and skyscrapers was gigantist. He was as racist and capitalist as John C. Van Dyke in his attitudes to the immigrant workers of the great cities. *The New New York* by Van Dyke, illustrated by Pennell, celebrated the power and energy of the city:

> There is nothing discreditable about commercialism. Material prosperity is what the world, in all times and all places, has been struggling for. The necessities of life are the prerequisites of the luxuries. No city ever did much with art and literature until it had solved the fiscal question.

Van Dyke had his own answer to the question of the human misery of the tenement dwellers:

> To the cry of Mr [Jacob] Riis, "Abolish the tenements!" there may be suggested an alternative. Why not abolish the tenants?[59]

Coburn's attitude toward the city was partly Whitmanian, partly apocalyptic or Futurist. Up to 1923 or 1924 he was still thoroughly optimistic. Only when signs of the Wall Street crash were on their way in 1927 did Paul Strand, for instance, reject the inequities of the urban, industrial world and set his face toward Mexico and an agrarian mode of life. Around the time of the Great War the idea of New York the Magnificent still prevailed. Robert J. Coady's little magazine *The Soil* (1916–17) celebrated the great bridges, the steam hammers, the tugboats, and the Woolworth Building and applauded the enterprise of the Panama Canal and the powerhouses of Pittsburgh and Duluth. Coburn's "Park Row Building" with its puff of smoke needs to be set next to his "St. Paul's" with its cloud of smoke to appreciate just how he accepted both the modern and ancient dispensations, Skyscraper Primitive and neoclassical. This he was doing several years before Coady and more than ten years before Charles Sheeler's painting of the Park Row Building with its Mondrianlike grid of windows. There is no evidence that Coburn was less capitalist than Pennell. He had a private income, like Stieglitz and Strand. Despite his contact with such socialists as Carpenter and Shaw he was probably still too young to have developed the social conscience of his old age. As a young man he was participating in the Futurist dream of the American skyline, even if he was to spend the largest part of his mature life in the remote vastnesses of North Wales.

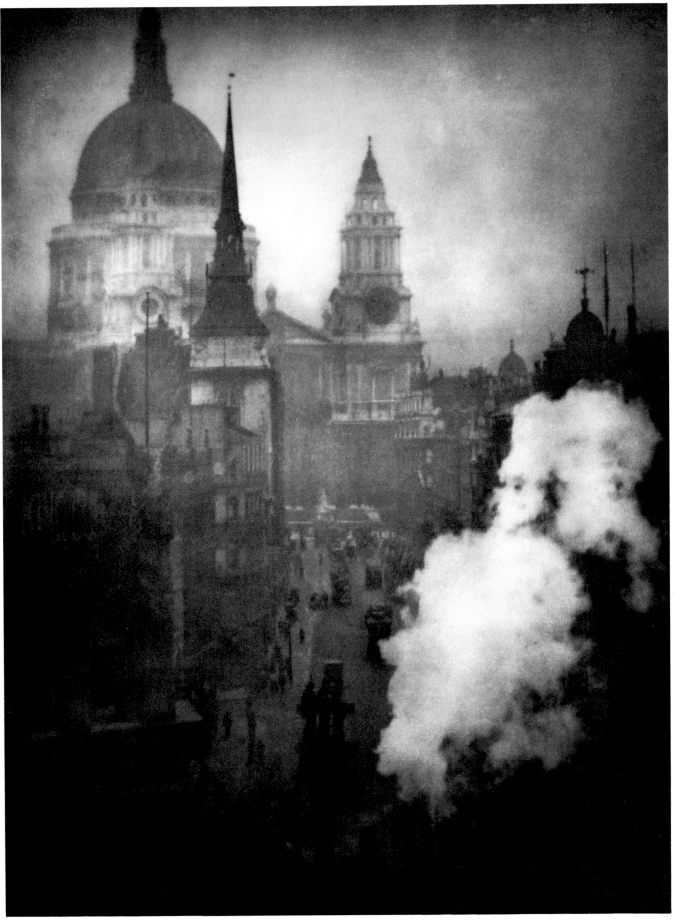

St. Paul's from Ludgate Circus, 1905 (Plate XX from *London,* 1909)

Kingsway, 1906 (Plate IV from *London*, 1909)

The Tower Bridge, c. 1906 (Plate VIII from *London*, 1909)

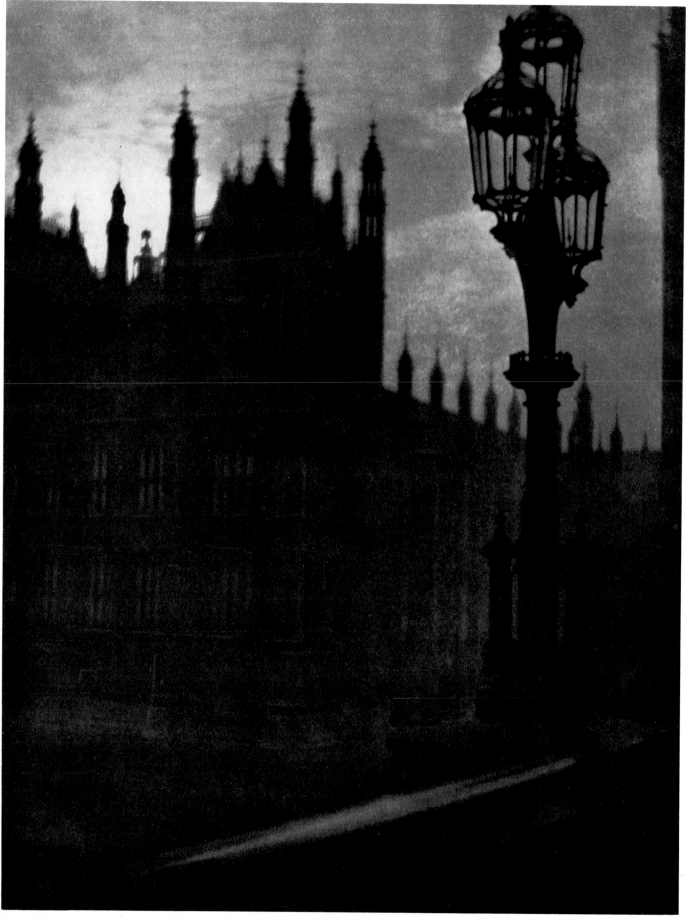

From Westminster Bridge, 1905 (Plate XIII from *London*, 1909)

Broadway at Night, 1909 (Plate VI from *New York*, 1910)

THE OPERATIVE OR CRAFTSMANLY QUALITY

That which we come to know *by means of science, we* apply *by means of art. Having extended our researches into the hidden mysteries of nature and science, we begin truly to qualify for mastership.*
Wisdom is the right application of knowledge; it is the marriage of science and art, the progeny of which are good, true and beautiful acts.—Alvin Langdon Coburn[60]

Coburn's best work was done in the period when the work ideal had not declined. He was an enthusiast for the new medium of photography, which alone, in his view, could deal adequately with the new city. Pennell fumed against such presumption. He lashed out at Coburn's patron, Shaw:

> . . . to this day he don't know the difference between a photograph and a painting, though he prefers the photograph, as his art writings prove and his portrait of himself, by himself, shows.[61]

But Pennell's rage was really vented on those who threatened his own field of magazine and book illustration. He had lived through the period when wood engraving, mezzotint, steel engraving, and lithography were being replaced by halftone photographic reproduction. He tackled the subject in several books on illustration through the nineties, when he also launched his attack on photography in the *British Journal of Photography.* In his view photography was a mechanical science without much handwork, and the moment any serious attempt was made to alter it by hand it ceased to be photography. "Photography is not a fine art, and never can be."[62] Coburn believed photography could be a fine art and take its place in the traditional graphic arts. It could be an extension of the very line that Pennell took. Coburn was adopting a moderate position between that of his early days in Boston, when he manufactured his own gumbichromate paper, and that of his Vorticist moment, when he advocated a purely optical approach to the medium. The form of presentation he was most firmly committed to throughout the most important years of his career, 1904–12, was the platinum print and the photogravure.

Coburn went to study with Frank Brangwyn in London because Brangwyn was the epitome of the William Morris type of craftsman—he had trained with Morris in his youth and had also founded the Chelsea Arts Club with Whistler. Coburn was not ashamed to reproduce the work of his friends Max Weber and Brangwyn by photography. In 1905 he published his reproductions of Brangwyn's Thamesside and Venetian work as a form of graphic art. He was taking his place in a long tradition of such representations of other artist's work in British photography that began with Roger Fenton and continued nobly with Frederick Hollyer and Frederick H. Evans. Coburn asked no more than to be considered an etcher-illustrator like Whistler, Pennell, and

Brangwyn. He agreed that photomechanical reproduction could be hideously inexpressive and without individuality of any kind but wanted it to be otherwise.

Of all the Photo-Secessionists Coburn was, like the Scotsman James Craig Annan, one of the few who obtained total control over the production of their photogravures and went beyond the exhibition print to present the work in magazine and book form. Annan, the same age as Stieglitz and Day, was instructed by the inventor of photogravure, Karl Klič, in Vienna the year after Coburn was born. From 1906 to 1908 Coburn attended the splendid London County Council School of Photo-Engraving and Lithography in Bolt Court twice a week whenever he was in town. W. J. Newton, the principal, was a constant contributor to the journal of the Royal Photographic Society on the subjects of orthochromatic plates and three-color printing. The school combined teaching craftmen their trade with such research. There were 336 students doing photoengraving, but when the principal's report for 1906–7 was issued, Plate II was "The Duckpond, photograph and photogravure etching by A. L. Coburn." He had managed to make his mark in his first year.

While Coburn was at the school John Threlfall and J. William Smith wrote a series of articles on photogravure for *The Process Photogram.*[63] Smith was one of his teachers at Bolt Court, and Threlfall supplied the gravures that Coburn sent to *Camera Work* in 1906. When Coburn moved to Hammersmith in 1909 he was able to set up two copperplate presses and produce the large *London* portfolio himself. He was in reach of achieving what his friend A. J. Anderson claimed was possible through photogravure:

> . . . that pictorial photography will offer a livelihood, and that photography has, at last, the chance to establish itself as an Art.[64]

Coburn etched and steelfaced some eighty-three plates from his own negatives in the period 1909–14; a printer then followed the pattern proofs Coburn had approved, and printed some 40,000 gravures. From an article Coburn wrote in 1913 it is clear that he regarded platinotype and photogravure as the two ideal ways to render a photographic negative, and "a photogravure may be so much like a platinum print that it is difficult to tell them apart." Without a magnifying glass this is undoubtedly true. Like the variation of the carbon process called Ozo-

The Copper Plate Press, self-portrait, 1908

type that Coburn had tried in 1902, photogravure etching combined the possibilities of simplification by elimination and local development with the capacity for as much richness and detail as was desired. Shaw wrote in the prospectus for Coburn's *London* book:

> Every step of the process has been carried out by himself in his studio with the artistic result aimed at constantly in view, thus placing the process on the artistic footing of etching, lithography, and mezzotint.[65]

There is no doubt that Coburn would have preferred to work solely in photogravure. Shaw had remarked that it cost more to make one gum-platinum print than twenty photogravures, so the process was certainly a step toward democracy, even if supervision of the printing was enormously time consuming.

Even more remarkable was Coburn's commitment to machine printing. Mezzogravure used a screen but managed to produce, according to Shaw:

> . . . the richness of a hand-printed plate, and possessing besides this, a new and very remarkable silk-like lustre in the high lights, due probably to the great pressure used in printing. A very beautiful process, I think you will admit, which will revolutionize and eventually displace that of the half-tone.

Coburn's smaller books, *London* (1913) and *Moor Park* (1915), were both printed in mezzogravure, but his enthusiasm for machine printing did not stop there. Rotogravure, employing copper cylinders rather than plates, could produce prints at the rate of six thousand an hour. So far as Coburn was concerned the results were perfectly acceptable. *Pall Mall* magazine issued a special supplement printed by this method, "consisting of four of my pictures which, as reproductions, compare very favourably with the originals."[66] *Photography and Focus* published eight photogravures for a penny. In 1913 a single hand-drawn gravure cost fifteen dollars and a platinum print fifty dollars. It is quite clear

that gravure was Coburn's preferred form of expression and that he wanted to extend the British tradition of photoengraving.

An unbroken line of experiment with reproductive processes by the most important photographers led from Talbot's photographs to Fenton's galvanographs, Cameron's carbon prints, Emerson's photoetchings, and Annan's photogravures. When Coburn chose a self-portrait at the copperplate press for the frontispiece of his autobiography, he offered it "as a testimony to the operative quality of my work in this field" of photogravure.[67] Frank Brangwyn and his assistant were also photographed at their copperplate presses, the assistant taking a pose very close to Coburn's.[68] James Craig Annan photographed an etcher studying his plate.[69] These images were demonstrations of intent that shifted the emphasis away from the creative moment of making the negative to the contemplative process of making the print. The meaning of the original could be refined, subtly improved, clarified, and imbued with feeling by the rhetorical effect of tonal variation.

The Symbolist circles in which Coburn moved in Boston, London, and North Wales were all devoted to music. Human consciousness could detect a nameless perfection in what appeared to be nebulous but was in fact a precise notation of feeling. Fenollosa compared the Japanese printmaker's work with that of Chopin in terms of visual and aural music. Symons preferred the musical artist of suggestion, a pianist like Vladimir de Pachmann, to the artist of statement, a composer like Richard Strauss. Coburn's friends, Shaw and Evans, joined him in passionate love of the Pianola, a player piano that Sir Henry Wood, the founder of the famous Promenade concerts, had endorsed. The relation of the pianist to the composer was paralleled by that of the photogravurist to the maker of the negative. By means of expression knobs, damper-pedal control, and tempo regulator, Coburn performed on Pianolas and concert grand pianos with player attachments with as much skill and emotion as he brought to his performances on the copperplate press.

Weir's Close, Edinburgh, 1905

*There is only one way in which symbols may be made truly living. One by one material things come to
be known for what they are, beautiful symbols of still more beautiful Realities. One by one they are
taken into the mind and their outward forms transcended until in the end only the Realities
themselves are contemplated, and at last the soul comes to behold the One Reality face to face, and
symbolism is overpassed.*—Alvin Langdon Coburn[70]

In October 1912 Coburn married Edith Wightman Clement of Boston in Trinity Church, New York.

> At this period I was far from well. How my wife (bless her) had the courage to marry me I often wonder, but she did.[71]

In an important sense this step marked the end of Coburn's photographic career. There were portraits to take, Vortographs to make, and Harlech and early British sites like Avebury to photograph, but marriage betokened psychological change. Rebellious youth gave way, at thirty, to the quieting of ambition in the wise care of a new maternal figure whom Coburn was now ready to accept. The next years until 1916 were spent producing books from work done almost ten years before, like *Men of Mark* and *Moor Park*, and organizing and making prints for his "Old Masters of Photography" exhibition, which toured the United States.

In 1916 Coburn was invited to Harlech by George Davison, whose great career in photography was now also finished. Davison occupied himself with the sponsorship of several groups making ways of life alternative to those of the establishment. He was seriously involved in the Labour movement, encouraged post-Symbolist music, and was host to a group concerned with comparative religious studies.[72] Cyril Scott and Sir Granville Bantock were two leading British composers in Davison's circle who shared Coburn's religious interests. Scott was a Theosophist of the Blavatskian school, but Coburn found this ecstatic path to wisdom ultimately too disquieting for himself. Although he and Scott were students of the occult together in 1916, when Coburn in 1923 finally found a road that satisfied him he looked back on those experimental years as a waste of time. He had even fallen for the idea of astrological portraiture, unlike David Octavius Hill when invited to consider the possibility of phrenological portraiture in the 1840s.

These follies ended when Coburn met the man who put him on the quietist path to wisdom. Through him Coburn joined the Universal Order, which dedicated itself to the study of sacred texts referred to collectively as *The Shrine of Wisdom*, which was also the title of the magazine issued by the group.[73] The group was intended to be not a popular religious movement but an anonymous society, and its magazine and other publications remain available today to those who want to broaden their religious knowledge without abandoning their own beliefs. Its explanatory leaflets explicitly reject spiritualism, occultism, astralism, magic, and parapsychology:

> The inordinate craving for the mysterious and extraordinary is a perversion of the soul's natural desire for the beautiful; because the more real mystery there is in a work of art the more intrinsic is the beauty that it holds.[74]

The emphasis is on devotional meditation on texts drawn from the great mystic traditions of the world: Hermetic (Hermes Trismegistus), Greek (Pythagoras and Plato), Neoplatonic (Plotinus and Thomas Taylor), Christian Neoplatonic (Dionysius the Areopagite and St. Paul), Chinese (Lao-tzu), Indian (the Gita), and Buddhist (the Mahayana school). That Coburn knew all these texts extremely well is certain. That he was one of the editors of the *Shrine of Wisdom* magazine seems extremely likely.

A close reading of Coburn's commentary to *The Classic of Purity*, attributed both to Lao-tzu and to Ko-hsuan, shows how committed to Taoism he was, but also how he was able to relate its tenets to those of the Mahayana school on the one hand and those of Dionysius the Areopagite on the other.

> Basically, there are two ways of approaching God, that of the *Via Affirmativa, in which the mind is concerned with what He is, in relation to that which the finite is not, and that of the Via Negativa, which denies of Him all finite limitations or attributes whatsover.*[75]

If we engage with Coburn's distinction and analogize this in terms of photography, the difference is between bringing a consciousness of universals to certain particulars in the visible world (the photographic affirmative or positive) and stripping away the external aspect of all particulars until universals are revealed (the photographic negative). The positive demands a strong idealizing principle to order it. The negative is an aid to abstraction because it inverts and reverses spatial organization and tonal relationships. The positive way requires knowledge of a preexistent order; the negative way stimulates discovery of such a pattern. Arthur Symons put it differently:

> All mystics being concerned with what is divine in life, with the laws which apply equally to time and eternity, it may

St. Paul's from Bankside, c. 1905 (Plate VIII from *London*, 1914)

happen to one to concern himself chiefly with time seen under the aspect of eternity, to another to concern himself with eternity under the aspect of time.[76]

The temporal emphasis is realist or positive in tendency, the eternal emphasis idealist or negative. But they are, as Coburn explained, complementary:

> The *Via Affirmativa* and the *Via Negativa* have also been termed two modes of Contemplation of the Divine; they are said to mark the equilibrating Pulse of the true Mystical Life.

The approach to the Light Unapproachable is as much the goal for the mystic as the Inexpressible Meaning is for the Symbolist. But it is not a matter merely of intellect; it requires intuition and feeling trained and enhanced by quieting the desires. Coburn rejected the idea of mystical experiences induced by drugs, saying that he would rather "come in by the front door" or not at all.[77]

Coburn's commentary on the *Yin Fu King* of the emperor Huang-ti further confirms his position:

> The wise may sometimes appear to be foolish and the foolish to be wise. But in apparent foolishness profound wisdom may be expressed and in apparent wisdom, great foolishness.[78]

Coburn's own autobiography appears to be an extraordinarily naïve document, but it is only as "foolish" as the Masonic writings are "wise." He had arrived at a stage when he regarded self-importance as nothing compared with Tao. The years of ambition, competition, egocentricity, and unnamed desires were past, but the wish to be remembered publicly for his photographs was not entirely stilled:

> The Soul of man loves purity, but his mind is often rebellious. The mind of man loves stillness, but his desires draw him into activity. When a man is constantly able to govern his desires, his mind becomes spontaneously still.[79]

What had gradually happened was that the expression of Coburn's true nature had shifted its ground. Up to the age of thirty he was a photographer-priest, as Sesshū was an artist-priest. From the time of his marriage he became increasingly a priest-artist like another, later Japanese painter, Sengai. The spiritual channel had been open all along, but when it found its religious outlet Coburn's photographic career was reduced to a hobby. The photographs became merely confirmations of what he already knew intellectually. They were no longer the uncertain adventures of his youth but didactic tools. In youth the symbol was as mysteriously real as the truth for which it stood, but in age the descent into allegory and emblem marked the diversion of Coburn's energies from the operative to the speculative mode.

Like *zenga* (Buddhist aesthetic objects for meditation), the Edinburgh and London photographs of the period 1905–9 contain pictorial themes applicable to Buddha-nature although they are embodied in the Judeo-Christian tradition. Consider "Parliament from the River," the image of the boat on the Thames in front of the Houses of Parliament, which, neo-Gothic in style, evoke the great cathedrals even though they represent only secular power. The Thames is the great flux. The clocktower of Big

Parliament from the River, c. 1906 (Plate VI from *London*, 1914)

Plate III from *The Cloud* by Percy Bysshe Shelley, 1912

Ben measures its passing. The spire, the aspiration of eternal truth, annihilates time. Man, anonymous and barely visible at the oars, must guide his soul-ship through the gulf that divides permanence from change.

The dome of St. Paul's Cathedral offered Coburn several opportunities for such metaphorical constructions. The possibilities of St. Paul's as a subject were known to others in the Coburn circle of photographers in London. Walter Benington gave it an Impressionist treatment.[80] Coburn framed it as if it was a Japanese temple in the manner of Hiroshige, but he also treated it as a Zen landscape and a Masonic emblem. In "St. Paul's, from Ludgate Circus" the vapor (*ch'i*, breath, air, even matter itself) from a locomotive ascends like a cloud—a manifestation of energy transformed. In the Zen, or Taoist, or Neoplatonic view of things the solid and the evanescent are one. A half dome as the circle of perfection, and a cloud such as a Japanese painter used to balance his space art, were equal in terms of matter and spirit. The cloud is a type form in Coburn, an idealized embodiment of transient effects.[81] But as a pictorial motif it should also be related to the flaming clouds in the Pittsburgh steelworks pictures of 1910. In Coburn's mind, poured steel ("White Hot") was connected with the power of a waterfall in Yosemite, just as a cosmic flame of molten metal ("The Melting Pot") was associated with a cloud form. Pillars of smoke and of cumulus cloud were ideally congruent. Like some ancient alchemist, the steelworker intervened in the energy exchange at the operative level.

> Behind and within every operative effect, there is a speculative, super-physical or spiritual cause. . . . To the Pythagoreans the spiritual significance of a geometrical truth was of far greater importance than its operative use, for from one such idea, innumerable practical examples could be worked out.[82]

In Freemasonry "operative" and "speculative" are used to distinguish between the practice of the operative craftsmen who built the cathedrals of Europe and the speculative philosophers who developed the idea of God as the Great Architect and Grand Geometrician. Coburn often quoted the definition of Masonry, "A system of morality, veiled in allegory and illustrated by symbols." It is a speculative theory of ethics represented to the initiated by means of ritual and emblems drawn from the operative field of classical architecture. Seventeenth-century emblem art was revived in the nineteenth century and even included imagery from the Industrial Revolution. Masonic elements derived from and contributed to this pictorial tradition: arches and bridges, domes and towers, steps and stairways, doorways and portals, fountains and rivers, groves and gardens, and natural and artificial temples, all of which are motifs in Coburn's work, are found in the emblem books. Moor Park—more a Renaissance palace than an English country house—was a perfect building for photographic treatment as a Masonic memory system.

Freemasonry is deeply established in British public life. It is no exaggeration to say that in Coburn's time very few prominent members of society were without knowledge of it. The kings of England and the archbishops of Canterbury were all Masons.

St. Paul's from the River, c. 1906 (Plate VI from *London*, 1909)

The Sphinx, The Embankment, 1905

Jews were admitted. Freemasonry was and remains a wholly respectable practice:

> Freemasonry in the good old easy-going pre-war days may have meant to many, a friendly gathering of brethren meeting for purposes of conviviality, with a background of charity and well-being.[83]

But Coburn, being American born, took it far more seriously than his new countrymen. To him it was a science of conduct and an art of living, the purpose of which was allegorical and the illustration of which was symbolical,

> for we use the operative paraphernalia of the builder's art to indicate the method of an entirely different edifice: a temple not made with hands, the edifice of our own spiritual life.[84]

Coburn's *London* portfolio does not require a specifically Masonic interpretation but may be usefully approached by using a similar system of allegory. For instance, "St. Paul's, from the River" may be read at several levels. Literally, it is a picture of St. Paul's Cathedral, Waterloo Bridge, and the River Thames. Figuratively, it unites a dome, a bridge, and a river. Allegorically, it offers a dome of knowledge, supported on pillars of Wisdom, over the Great Flood. Anagogically, it shows eternity triumphing over time. In this image, which Coburn used on the cover of the prospectus written by Shaw for the *London* portfolio, the telephoto lens has so arranged the view that the dome appears to rest on top of the bridge. The strong black line of the balustrade of the bridge separates the Above from the Below in Hermetic terms or in Chinese terms of yang and yin, but "these are in reality always perfectly integrated, for they subsist ideally in the spiritual realms."[85] But in this particular case a Masonic interpretation is probably more apt, because the architect of St. Paul's, Sir Christopher Wren, was initiated as a Mason in 1691. That Coburn could publish the picture in the *Daily Graphic*[86] shows that such an image could be safely displayed before the public while concealing its true meaning for the initiated.

The Knights Templar lived in the sanctuary of the Middle Temple throughout the fourteenth century, and Coburn photographed the later entrance built by Wren. The associative power of this structure so close to Fountain Court would not have been lost on him. Chivalric orders like that of St. John of Jerusalem and Manichean sects like the Albigenses had recourse to such places of sanctuary and concealment to protect themselves from persecution. But Coburn would have disapproved of the dualism of the Albigenses: to him evil was merely the absence of good, not a reality. If in 1916 Ezra Pound was willing to call Coburn what he would call very few, "Magister,"[87] and one of their shared interests was Fenollosa and Eastern thought and another was G. R. S. Mead and Gnostic philosophy, yet another may have been Harold Bayley's investigations into the lost symbolism of the Albigenses, *New Light on the Renaissance* (1909) and *The Lost Language of Symbolism* (1912). If the Templars were an order of chivalry that appealed to Coburn, the Albigenses were an order of education that appealed to Pound. In Avignon these Provençal illuminists expressed in papermarks and woodcuts their secret beliefs, combining Platonism with Christianity in a new intellectual system. The very word "symbol"

finds its origin in "password" or "watchword" as well as in secret marks on vases, watermarks in paper, wedding rings, and other tokens. Bayley ended *New Light on the Renaissance* with a passionate appeal to contemporary artists to continue the secret tradition of the Albigenses:

> The Church of the Holy Grail has broken the conditions which once fettered her, but her enemies, though now less material, are still ruthless and malignant. To contend with them successfully, the Church of the Future must cancel the unwarrantable distinction between "secular" and "sacred," and must re-enlist her old-time emissaries the Musicians, the Dramatists, the Novelists, the Painters, and the Poets.[88]

Among the symbols that Bayley illustrated were variations on the scale of perfection, or Jacob's ladder. Coburn himself referred to life as a ladder: ". . . its lowermost extremity rests upon the foundation of the earth, but it ascends even unto heaven." The development of the soul depended on an ever ascending scale of faculties and power, but the ways of ascent were many.[89] The Sphinx at the top of the steps in the photograph "The Sphinx, The Embankment" is the symbol put before a temple by the Egyptians to warn the priests against revealing divine secrets to the profane. "The Steps to the Sir Walter Scott Memorial" lead not to the neo-Gothic monument itself but to a tree, an archetypal motif of Gothic architecture. Another version of the ladder of ascent has, above some steps on Riverside Drive in New York, a viewing point built in Japanese style. Bayley's versions have at their topmost points a cross, star, or fleur-de-lis, all emblems of Christ. The surmounting elements in Coburn's designs are spiritual truths symbolized in terms of various religious or mystery systems.

In "The Enchanted Garden" two separate goals are embodied in the same image. On the left a set of steps leads to a figure of Hermes, which typifies the step-by-step approach to the goal; on the right is an illuminated clearing, which typifies the attainment of the goal by the lightning flash of intuition. In China, Northern Zen achieved its goal by the gradual method, whereas Southern Zen preferred sudden enlightenment. In his later life Coburn preferred the wisdom attained by scholarship, but in his photographic career he was more open to ephemeral manifestations in nature. The two methods result in a combination of the monumental with the lyrical. At the foot of the steps is a dark patch symbolic of the invisible presence of the person about to begin the ascent. Masonic emblems often show two figures, one a guide and the other an initiate, standing at the foot of a stairway between two pillars of a porch on the threshold of the initiate's spiritual ascent.[90] At the top of the stairs a Master Mason draws back the veil that conceals the mystery. Coburn did not attempt this kind of allegorical scene with figures, although in the Moor Park photograph "The Edge of the Garden" a silhouetted figure or a fountain, with the ladder motif represented by a low stone projection, may suggest the invisible goal and a token presence.

"Weir's Close" was singled out by Alfred Stieglitz as especially fine.[91] But what did he see in it? Was it the wit of the relation between the light of the sun and man's feeble imitation of it, the gaslight? Was it the great arrowhead of light formed by

The Edge of the Garden, c. 1906 (Plate IV from *Moor Park*, 1915)

The Enchanted Garden, c. 1906

The Steps to the Scott Memorial, 1905
(Plate XVIII from *Edinburgh* by Robert L. Stevenson, 1954)

two planes plunging in reverse perspective down right? Did Stieglitz note the significance of the two steps rising to a door in relation to the barred window? This stage set without actors rivals "Fountain Court" as Coburn's greatest Symbolist picture, an inexpressible combination of sensuous beauty with intellectual suggestion.

In terms of symbolism the twin towers of "Westminster Abbey" evoke the Castle-Temple that in the Christian tradition represents the summit of moral achievement and sanctity of life. In combination with the towers, the streetlamps, which contain globe-and-cross forms, typify enlightenment. In "Trafalgar Square" the reflections of the fountain and the column are so related as to evoke the candlestick, which is in all the mystery religions the emblem of good works. This time the invisible presence is the defender of the British Empire, Nelson himself. "The British Lion" is an allegorical picture. Literally, it shows the Victorian artist Sir Edwin Landseer's sculpture together with the cupola of the National Gallery. Figuratively, military power protects the treasure house of civilization. Anagogically, the principle of spiritedness guards the ideal of art: the lion, it had been believed since ancient times, slept with its eyes open.

If London was full of emblematic possibilities, New York may have offered fewer at first sight. Nevertheless, in the photograph Coburn titled "The Octopus," the shadow of a pinnacle superimposed on part of a series of paths in the form of a wheel may refer obliquely to the idea of the point within the circle.

> The Point within a Circle is both a human and a Divine symbol. With man the point is Spirit and the circumference is body; and the soul, that mystery with its centre everywhere and its circumference nowhere, joins the two.[92]

Equally, the pinnacle may evoke the dark threat of material power on the white light beneath the solar wheel, which may be either the mark of the learned school of St. Catherine or the excellent wheel of good law. The sun wheel appears as a motif in Coburn's portrait of the photographer George H. Seeley as a Symbolist evocation of this kind. When Coburn used the title "The Octopus" he imagined the creature in the same hieroglyphic context as the lion, the dragon, and the eagle.

A remarkable picture of the Singer Building aspiring vertically and the street below running horizontally, making a triangle or V-shape in two planes, with the slightest hint of the displaced Trinity Church at the left edge of the picture, may evoke the branching paths of spirituality and materialism in the modern world. "The Two Trees, Rothenberg" offers a simplified version of a V-shape with the spire of the church rising between the trees. "The Woodland Scene" uses that shape to usher in the moonlight to oppose the darkness. Ezra Pound's image among the Vortographs may be a parody by Coburn of the kind that he made of Mark Twain as an Eastern sage. Pound is divinely favored many times over by means of the multiple exposure of his triangular collar points. But the crown of deification that usually accompanied these triangles with twin globes of love and knowledge—his spectacles—somehow eluded him here, even as it did in life.

If the V-shape of Pound's collar did not stand for spirituality, perhaps it stood for Vorticism, a word that Pound coined to describe London's contribution to Cubo-Futurism. Coburn's Vorti-

Westminster Abbey, 1905

Trafalgar Square, c. 1905

The British Lion, 1905 (Plate XIX from *London,* 1909)

The Singer Building, Noon, 1909

cist career lasted all of one month at the beginning of 1917. Under the influence of Ezra Pound—who had been hustling to invent first Imagism and then Vorticism—and having finished his major work and not yet settled in the path of his future life, Coburn tried to find his way into the vortex of literary London. He had made portraits of Wyndham Lewis and Edward Wadsworth that included their Vorticist paintings as backgrounds.[93] In *Punch* magazine there was already in June 1914 a cartoon, "The Cubist Photographer," in which a large prism was shown set up between camera and sitter, with a series of multifaceted images on the wall of the studio.[94]

Coburn had helped pay for the publication of Max Weber's *Cubist Poems* (1914), and probably took his modernist principles from him rather than Pound. At the Clarence White School of Photography in New York, Weber had encouraged the students to bring as much abstraction as possible into their work. The emphasis was on design rather than representation. Coburn saw these exercises at an exhibition of the Royal Photographic Society in 1915, and some were published in the magazine of the Pictorial Photographers of America, *Photo-Graphic Art,* for which Coburn was the London correspondent.[95] An unsigned article in the same issue cautioned against unthinking and willful overproduction in photography. The young photographer had to decide "whether his presence in photography is to contribute to its advancement or to join those who are conducting an aimless existence."

The terrors of an aimless existence confronted Coburn. Steichen faced the end of Pictorialist photography by studying art forms in nature and new ideas about proportion. This intelligent decision helped develop the metamorphic tradition that would sustain two generations of American photographers, from Edward Weston to Paul Caponigro.[96] It represented a firm commitment to realism in photography. But the idealist tendency in Coburn's personality was too strong to allow him to make the transition from Pictorialism to straight photography. From the beginning of his career to the very end it is clear that he was progressing down a road to pure idealism. Vorticism represented the moment when he arrived at extreme abstraction in photography.

Steichen had been able to continue because he was able to adjust to new photographic conditions—the new bromide papers, the new objectivity—and find metamorphic meaning in the appearances of nature. Coburn could not. He attempted in the Vortograph to turn his Symbolist approach, already heavily slanted in favor of idealism, into a formula. He no longer allowed the inner forms in nature to interact with its outer aspects but imposed his idealist will on it. If Pound was an idealist posing as a realist, Coburn was never anything other than the complete epopt who dealt in mysteries. Dematerialization or idealization was his aim. While this was restrained by his relation to the Pictorialist tradition, he could work against its conventional aspects to wonderful effect; but when he broke with that tradition, his ideal philosophy turned his work into ciphers of no importance to anyone other than himself. Vorticism marks the moment when he briefly despaired of being able to consider outer phenomena as other than distorted aspects of an ideal geometry. The Vorticists, organized by Pound and Wyndham Lewis, produced an exhibition in June 1915, and two issues of a

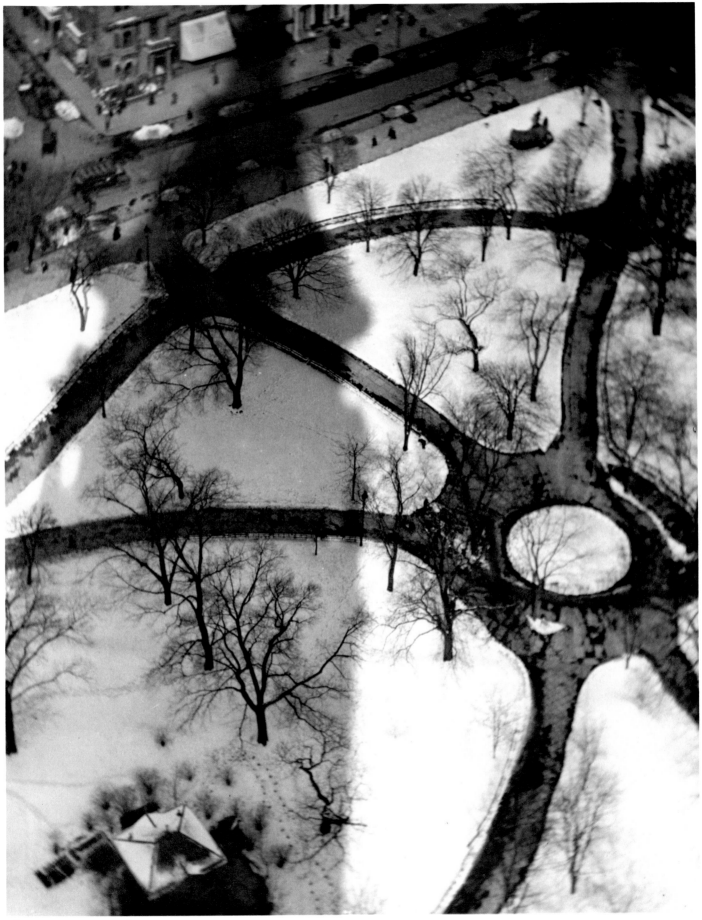

The Octopus, New York, 1912

The Two Trees, Rothenberg, 1908

The Garden by Moonlight, c. 1907 (Plate from *The Door in the Wall,* 1911)

Original ink drawing by Alvin Langdon Coburn used
on the cover of the pamphlet for his exhibition
"Vortographs and Paintings" at the Camera Club, 1917

visually derived from the drawings by Jacob Epstein for his
Rock-drill (1913–15). Pound's knowledge of photography was extremely limited:

> Art photography has been stuck for twenty years. During that
> time practically no new effects have been achieved. Art photography is stale and suburban.[97]

To say that photography had made no progress since 1897 was
nonsense, but Pound wanted to negate the influence of Impressionism with Vorticism:

> . . . pleasure is derivable not only from the stroking or
> pushing of the retina by light waves of various colour, BUT
> ALSO by the impact of those waves in certain arranged
> tracts.

But Coburn's "Station Roofs, Pittsburgh" (1910) and pictures of
New York from its pinnacles showed that he was perfectly capable of arranging his compositions in Vorticist tracts even if their
origins were in Japanese composition rather than Italian Futurism. Key words like "impact" in Pound's writing and his attacks
on "blur" show that he was rejecting caressive and maternal
Impressionism in favor of the clean thrust of Vorticism. He cultivated the idea of the hard edge. The sexual overtones of Vorticism, the protofascist cult of the male and of the warrior, are
inescapable. The true mystery of life for Pound was coitus, and
his hieratic head carved in stone by Gaudier was a monument to
his cold phallicism. Pound wrote:

> The modern will enjoy Vortograph No. 3, not because it reminds him of a shell bursting on a hillside, but because the
> arrangement of forms pleases him, as a phrase of Chopin
> must please him. He will enjoy Vortograph No. 8, not because it reminds him of a falling Zeppelin, but because he
> likes the arrangement of its blocks of dark and light.

Note that, despite his attack on representation, Pound was still
forcibly reminded of concrete phenomena but rejected the shell
in favor of Chopin, the zeppelin in favor of light and shade.

The proneness of the human mind to find meaning is, happily, inextinguishable. We will continue to like things because we
recognize them, even as we enjoy our sensitivity to the forms
that bring them into our minds. The joke is ultimately on
Pound: we will never again look at "Vortograph No. 8" without
thinking of a zeppelin. After more than half a century of blocks
of dark and light we are not impressed by them alone. The saddest aspect of Coburn's experiments is that they took place at
the moment when the image produced by the Vortescope most
resembled what he knew to be preexisting Vorticist imagery.
The Vortographs are wholly derivative and deflect us from Coburn's great work as a photographer.

The idea of the bursting shell and the falling zeppelin should
be compared with Coburn's "The Death Glide" (See: Page 80).
If the Vorticist emphasized the orgasmic nature of death,
the Symbolist stressed a less dramatic transition from one
spiritual state to another. Pound conceived of woman as an
octopus[98]—a chaos requiring the weightless shadow of the phallus to bring her to law and light. Coburn's octopus photograph
was not based on such an attitude. He was a quietist in both sex
and religion. The aggressive phallicism of the Vorticist was alien
to his nature. When he introduced himself to George Meredith,

magazine, *Blast,* in which, among others, Frank Brangwyn was
"blasted" as out of date (in fact, he was at the height of his
fame). But the new tyros of the art world were determined to
have a movement, like the French, Germans, and Italians, no
matter how alien such a concept is to the British, and Coburn
had to join or be blasted, too.

Pound contributed an anonymous introduction to Coburn's
exhibition "Vortographs and Paintings" at the Camera Club in
London in February 1917. Coburn added a postscript in which
he expressed his realization that he had been used to further
Pound's movement. The paintings he had made in the summer
of 1916, before he had the benefit of the Vortescope—the combination of mirrors that produced the pseudoprismatic image of
the Vortographs—were Post-Impressionist. They were decorative, artificial in color, yet related to reality, so Pound excluded
Coburn from the Vorticist group of painters. Coburn's ink drawing on the cover of the catalogue was closer to a design for a kimono by the painter Paul Signac than to anything by the Vorticist painters or by the Vorticist sculptors Henri Gaudier-Brzeska
and Jacob Epstein. The eighteeen or so Vortographs Coburn
made can be divided into three principal groups. The first group
consists of a two-dimensional set of lines with an image of
Pound in silhouette. They are flat designs. The second group, in
which multiple exposure was added to the mirror effects, shows
an increased number of overlapped diagonal lines in the manner
of Lewis's *Composition* (1913), for instance. The third group is

Ezra Pound, 1916

Vortograph No. 8, 1917

Vortograph No. 3, 1917

Vortograph, 1917

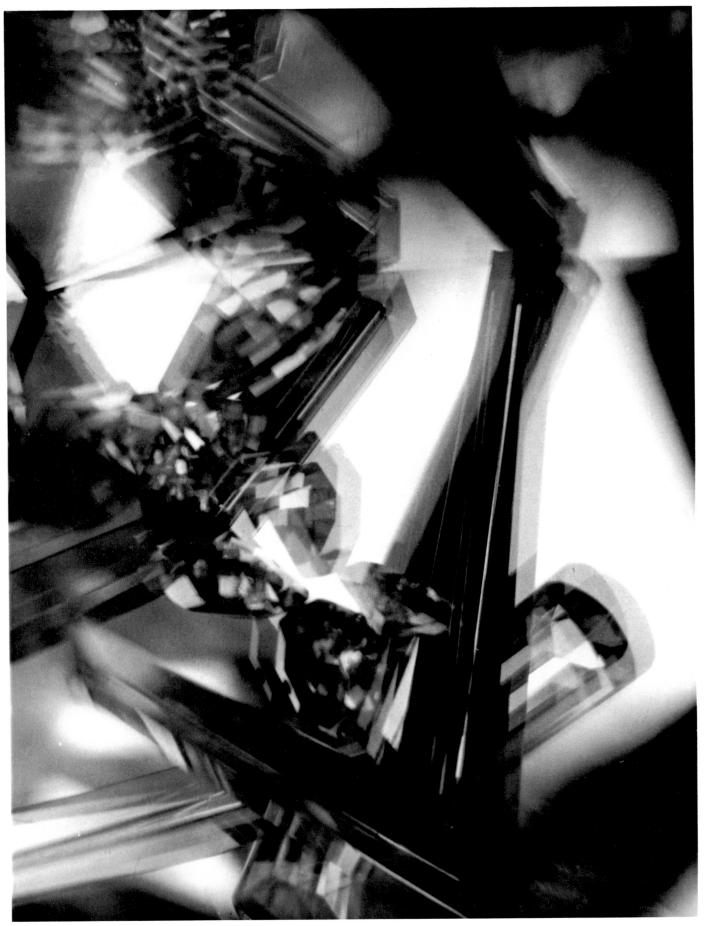

Vortograph, 1917

the poet of *Modern Love*, he did so by sending him a photograph of a golden-haired young mother giving her infant the breast. His interest in Lewis Carroll's photographic work, with its fixation on prepubescent girls, is an indication of his sexual immaturity. He was not an aggressively heterosexual figure like Pound, Stieglitz, or Steichen, but treated marriage and religion as a solution to his personal problems. The way Coburn wrote about his wife was extraordinary:

> She did not have any children of her own, but she would have made a lovely mother, and much of her maternal feeling was lavished on this unworthy little boy, which I did my best to appreciate.[99]

When Pound was broadcasting on behalf of Mussolini during World War II, Coburn was turning his home in North Wales into a hospital for the Red Cross. The men's essential natures had achieved final expression.

Whether a certain romantic, sexual agony is necessary to the production of art is an old question. At about the same time that Coburn was finally giving up art for religion in 1924, the American poet in the Stieglitz circle, Hart Crane, author of *The Bridge,* was disputing this subject with Gorham Munson, an important man of American letters in the twenties. Munson understood that early life influences begun in vanity, pride, and ambition sometimes mature under the influence of art and religion and strike a level of consciousness that he called the influence of an occult school. What gripped young Americans in 1924 was the development of P. D. Ouspensky's ideas by G. I. Gurdjieff, as disseminated by the English writer A. R. Orage, who was then in New York giving demonstrations and lectures on the Harmonious Development of Man. In Britain, Coburn was coming under the analogous influence of such a school. But unlike Crane, who came to resent and reject the influence, Coburn took to it utterly. Crane argued that the discipline of self-knowledge, the eradication of the self that plagued and vexed the soul, stopped people from writing. As Munson put it:

> Discipline suggests a price to be paid. The passivity and inertia of one's psychology resist discipline. There is a fear of losing the life one has. Man is strangely attached to his weaknesses. Sometimes he would like to grow out of them, but not at the price of hard struggle against them. In a crisis of life-change men find that they love their suffering and are fearful of the vista of a new life.[100]

Crane, who was homosexual, would not pay the price—drink and probable suicide followed as he tried to keep writing in the life image of the poet Rimbaud. Coburn was willing to pay the price—calm and contentment followed, but no photography to speak of. He had exchanged the Symbolist sensibility—immaturity, vexation, and all—for the concept of Awen (the name he gave his last house in North Wales). *The Shrine of Wisdom* described Awen as the Druidic principle of unity within the soul, the principle by which individual consciousness is united with God:

> According to the Ancient Bards, the presence of Awen is to be realized "by habituating one's self to the holy life, with all love towards God and man, all justice and mercy, all generosity, all endurance, and all peace, by practising the good

disciplinary arts and sciences, by avoiding pride, cruelty, uncleanness, killing, stealing, covetousness, and all injustice; by avoiding all things that corrupt and quench the light of Awen where it exists and which prevent its participation where it is present."[101]

Discipline of this kind resulted ultimately in a sterilizing puritanism that Coburn welcomed and Crane fiercely rejected. One of them lived to be eighty-four, the other died at thirty-three. As "young Parsifal" and "the Hustler" Coburn had suffered. As a member of the Universal Order he found a way to still his desires and attain peace of mind. The Symbolist photographer became the Mason, the devotee of Japanese art became the Taoist, and the Bostonian comparative religionist found a home in the Church in Wales.

As a Symbolist photographer Coburn was influenced by spiritual values and a concept of hidden knowledge but kept up his endless search for meaning in nature. A degree of agony was grist for his mill. The assumption of being in possession of meaning and having attained enlightenment leads to the complacent idea that one is a complete or perfected person whose role is to teach others. The mystic may continue to be an artist, but the mystagogue must be a teacher. Hart Crane expressed a healthy resentment toward the mystagogue. Coburn undoubtedly became a teacher, though not, of course, of the monologic kind like Gurdjieff. The Universal Order was dialogic and was committed to avoiding all cults of personality.

When the history of modernism comes to be written from a religious rather than formalist point of view, it will be seen that abstract artists like Kandinsky, Mondrian, and Malevich proceeded from symbolic rather than abstract ideas. Far from being formal experiments, their work was based on spiritual and utopian ideas. Equally, it is possible to see Coburn's work as the logical extension of his decided tendency toward the gradual elimination of the facts of nature in favor of its mysterious appearances, which early on had led to a concern, stimulated by Dow, with pattern, decoration, and design but, under the influence of Symons, never out of touch with reality. Coburn's emphasis was, in the end, on a municipal rather than an abstract sublime. He did not, like Mondrian and Malevich, construct an abstract language in which to represent spiritual ideas but considered the visible, urban world a conjectural rather than absolute symbol of the invisible. He subscribed to a theory of expression rather than of abstraction. The Vortographs represent a momentary lapse in favor of abstraction, when evoked meaning gave way to pure form.

If an *objet d'art* is a created artifact and an *objet trouvé* is an object found in the world, there ought to be a name for an object that is both made and found at the same moment—an object transfigured rather than manipulated, presented rather than represented, inscribed rather than described. To see a naturalistic object in a new light, under this transformed aspect, is the great gift within the power of a fine photographer. To make such a picture is to know enough. To know too much is to stop responding to nature in favor of merely contemplating it. By 1924 Coburn was indeed the man who knew too much. The animus of art had been finally subsumed under the mental impulse of religion, and his ethical development had assuaged his need to participate further in the competitive world of photography.

NOTES

1. A. L. Coburn, "Pythagoras," *Transactions of the Merseyside Association for Masonic Research*, XIX (April 1941), p. 26. 2. E. Jussim, *Slave to Beauty* (biography of Day) (Boston, 1981), p. 195. 3. A. K. Hammond, "Frederick H. Evans: The Interior Vision," *Creative Camera* (London), 243 (March 1985), pp. 12–26. 4. Compare Day's mother and child, 1905 (Jussim, plate 41), with Coburn's "Mrs. Murchand and Baby," June 1903. 5. Unsigned, "A Bit of Coburn," *Camera Work*, XXI (January 1908), p. 30. 6. Gleaned from Coburn's letters to Stieglitz, often undated (Beinecke Library, Yale University, New Haven, Conn.). 7. (Dixon Scott), "The Painter's New Rival—Colour Photography, an Interview with A. L. Coburn," *The Liverpool Courier*, October 31, 1907; reprinted *American Photography*, II/1 (January 1908), pp. 13–19. 8. G. B. Shaw, *Collected Letters* (London, 1972), p. 704. Letter from Stieglitz to J. D. Johnston, June 25, 1924 (Royal Photographic Society, Bath). 9. J. B. Kerfoot, "Black Art," *Camera Work*, VIII (October 1904), p. 31. 10. H. W. Lawton and G. Knox, eds., *The Valiant Knights of Daguerre* (Berkeley, 1978), p. 102. 11. *The Shrine of Wisdom*, Altrincham, London, etc., I–XXVIII (1919–47). 12. I was kindly received by the Universal Order, to which this man and Coburn both belonged, and shown a photograph of the man but not permitted to know his name on account of the order's strict doctrine of reserve and anonymity. 13. Karl von Eckurtshausen, *The Cloud upon the Sanctuary* (London, 1909). 14. M. Weaver, "The Metamorphic Tradition in Modern Photography," in *Creation: Modern Art and Nature* (Scottish National Gallery of Modern Art, Edinburgh, 1984), pp. 84–94. 15. A. L. Coburn, "The Future of Pictorial Photography," *Photograms of the Year* (1916), p. 23. 16. This paragraph answers the religious viewpoint of an anonymous article, "A Study in Graphic Symbolism," *The Shrine of Wisdom*, VIII/30 (Winter Solstice 1926), p. 177. 17. A. L. Coburn, "Pythagoras," p. 25. 18. A. L. Coburn, *More Men of Mark* (London, 1922), p. 13. 19. S. Hartmann, *Japanese Art* (London, 1904), p. 163. 20. A. W. Dow, *Composition: A Series of Exercises in Art Structure* (Garden City, N.Y., 1913) (all quotations from the seventh edition, revised and enlarged). 21. Hokusai, "In the Mountains of Tōtōmi Province," No. 2 of *The Thirty-six Views of Mt. Fuji* (1823–31). Note the analogy between smoke and cloud, as in Coburn's "St. Paul's, from Ludgate Circus" and "Park Row Building." 22. W. J. Naef, ed., *The Collection of Alfred Stieglitz* (New York, 1978), pp. 302–3. 23. T. Dallmeyer, *Telephotography* (London, 1899), Plates XXIII–XXV; see also Plates XVI and XVII as relevant to Coburn's "California Hill-Top" and "The Octopus." 24. "Ferry at Haneda," in *One Hundred Views of Edo* (c. 1858). Compare also Coburn's "The Prow" (1906) with Seurat's *The Harbor at Honfleur* (1833) and with Hiroshige's "Wagonwheel on the Beach at Takanawa" in *One Hundred Views of Edo*. 25. No. 52 of *One Hundred Views of Edo*. 26. "Hakone: The Lake Scene," *The Fifty-three Stations of the Tokaido*. 27. Letter from Dow to Coburn, January 31, 1910 (George Eastman House, Rochester, N.Y.). 28. A. J. Anderson, *The Artistic Side of Photography* (London, 1910), p. 182. 29. "A Study in Graphic Symbolism," *The Shrine of Wisdom*, VIII/30 (Winter Solstice 1926), p. 177. 30. M. Maeterlinck, "Emerson," *Poet-Lore*, X/1 (1898), pp. 76–84. 31. E. Carpenter, *The Art of Creation* (London, 1904) (all quotations from this edition). 32. C. H. Caffin, "Symbolism and Allegory," *Camera Work*, XVIII (April 1907), p. 17. See also Caffin, "Of Verities and Illusions," *Camera Work*, XII (October 1905), pp. 25–29. 33. S. Hartmann, *The Whistler Book* (Boston, 1910), p. 67. 34. C. H. Caffin, "The Development of Photography in the United States," in *Art in Photography*, C. Holme, ed. (London, 1905), American section p. 7. 35. Dixon Scott interview, *American Photography*, II/1 (January 1908), pp. 18–19. 36. A. L. Coburn, "The Question of Diffusion," *Semi-Achromatic Lenses*, Pinkham & Smith brochure (Boston, c. 1908). 37. Letter from Coburn to J. D. Johnston, December 13, 1907 (Royal Photographic Society, Bath). 38. C. Holme, ed., *Colour Photography* (London, 1908), pp. 1–10 (all quotations from the introduction by Dixon Scott). 39. A. J. Anderson, p. 230. 40. A. Symons, "Maeterlinck as a Mystic," *Contemporary Review*, LXXII/381 (September 1897), p. 349. 41. A. L. Coburn, "Photography and the Quest of Beauty," *The Photographic Journal*, XLVIII/4 (April 1924), p. 159. 42. *The Century*, XXXVII (December 1888). 43. J. Pennell, "Skyscrapers of New York," *The Century*, LXIX (March 1905), pp. 776–86. 44. James's letters to Coburn, now in the Henry James Collection of the Clifton Walter Barrett Library of the University of Virginia Library, Charlottesville, were freely quoted by Coburn in his broadcast for the BBC, "Illustrating Henry James by Photography," April 2, 1953, and in his 1966 autobiography, *Alvin Langdon Coburn: Photographer* (New York, 1978). 45. Ibid. 46. H.

James, *English Hours* (London, 1905), p. 16. 47. Coburn bequeathed his copy to the University Library, University of Reading, England. 48. A. L. Coburn, *Men of Mark* (London, 1913), p. 30. 49. A. Symons, *London: A Book of Aspects* (London, 1909), p. 4 (all quotations from this edition). 50. "Edgware Road" is in the University of Reading copy but not in the *London* portfolio as published. 51. Letter from James to Coburn, October 14, 1909 (University of Virginia Library, Charlottesville). 52. A. L. Coburn, "The Relation of Time to Art," *Camera Work*, XXXVI (October 1911), p. 73. 53. A. L. Coburn, review of International Exhibition of Pictorial Photography in Buffalo, *Harper's Weekly*, November 26, 1910. 54. Weber interview with Peter C. Bunnell, Great Neck, N.Y., September 8, 1960, by kind permission of Professor Bunnell. 55. A. L. Coburn "The Relation of Time to Art," *Camera Work*, XXXVI (October 1911), p. 72. 56. J. Pennell, *Pictures of the Wonders of Work* (London, 1916), pp. 10–13. 57. F. Brangwyn, *Catalogue of the Etched Work* (London, 1912); see Plates 43, 73, 76. 58. Amber Reeves, "The Finding of Pictures," *The Lady's Realm*, XXV (1909), p. 457. 59. J. C. Van Dyke, *The New New York* (New York, 1909) pp. 147, 261. 60. A. L. Coburn, "The Living Symbols of Freemasonry," *Transactions of the Manchester Association for Masonic Research*, XXV (1935), p. 53. 61. J. Pennell, *Adventures*, p. 160. 62. J. Pennell, "Photography as a Hindrance and a Help to Art," *British Journal of Photography*, XXXVIII/1618 (May 1891), p. 294. 63. *The Process Photogram*, July, August, September, and October 1907. 64. A. J. Anderson, p. 53. 65. A. L. Coburn, autobiography, p. 74. 66. A. L. Coburn, "Photogravure," *Platinum Print* I/1 (October 1913), p. 2. 67. A. L. Coburn, autobiography, p. 76. 68. Rodney Brangwyn, *Brangwyn* (London, 1978), facing p. 96. 69. *Camera Work*, XIX (July 1907). 70. A. L. Coburn, "Living Symbols of Freemasonry," p. 55. 71. A. L. Coburn, autobiography, p. 88. 72. "A Summer Retreat for Mystics" was organized by the Shrine of Wisdom in Harlech in the summer of 1924, "in the vicinity of ancient Druidic Remains." 73. The group incorporated the Hermetic Truth Society and the Order of Ancient Wisdom. Advertisements in the magazine show that it had contacts with other groups through their magazines, notably G. R. S. Mead's *The Quest* and D. T. Suzuki's *Buddhist Quarterly*. 74. The Universal Order, "On the Ideals, Purpose, System and Membership," Leaflet No. 1 (1924), p. 13. 75. A. L. Coburn, *The Classic of Purity* (The Shrine of Wisdom, 1934; reprinted 1980), p. 4. 76. A. Symons, "Maeterlinck as a Mystic," p. 357. 77. Letter from Coburn to P. H. Newby, December 19, 1953 (BBC Written Archives, Caversham, Reading). 78. (A. L. Coburn), *Yin Fu King* (The Shrine of Wisdom, 2nd ed. 1960), p. 13. 79. *The Classic of Purity*, A. L. Coburn, The Shrine of Wisdom, 1934, p. 6. trans. 80. See M. Weaver, *The Photographic Art* (London and New York, 1986), Plate 20. 81. Coburn ultimately found clouds too beautiful to think of them as obscuring the truth, which was the European use of them in the fourteenth-century English book *The Cloud of Unknowing* and in the *Cloud upon the Sanctuary* (See note 13 above). 82. A. L. Coburn, "Pythagoras," p. 22. 83. A. L. Coburn, "Freemasonry in Times of Stress," *Transactions of the Manchester Association for Masonic Research*, XXX (1940), p. 21. 84. I am not a Mason but would remind the reader that Masons were among the first to be persecuted in Nazi Germany and Vichy France. The British Labour party's 1985 proposal to forbid Masonry to its members can only be seen as a new threat to the human right to freedom of religion. 85. *Yin Fu King*, Coburn's introduction, (The Shrine of Wisdom, 2nd edition, 1960), p. 7. 86. London, October 23, 1909. 87. Inscription dated April 1916 in a presentation copy of Ezra Pound's *Gaudier-Brzeska* (London, 1909) (private collection). 88. H. Bayley, *New Light on the Renaissance* (London, 1909), p. 231. 89. A. L. Coburn, "The Living Symbols of Freemasonry," p. 53. 90. A. E. Waite, *The Secret Tradition of Freemasonry* (London, 1911) (2 vols.), I, p. 140. 91. Letter from Stieglitz to J. D. Johnston, June 25, 1924 (Royal Photographic Society, Bath). 92. A. L. Coburn, "Substituted Secrets," *Transactions of the Merseyside Association for Masonic Research*, XXV (September 30, 1947), p. 41. 93. See A. L. Coburn, *More Men of Mark*. 94. p. 480. 95. *Photo-Graphic Art*, III/2 (October 1917), n.p. 96. M. Weaver, "Curves of Art," in the Weston Centennial issue of *Untitled* (Friends of Photography, Carmel), 1986. 97. (Ezra Pound), "Vortographs and Paintings by Alvin Langdon Coburn," *The Camera Club* (London), 1917, p. 5 (all quotations from this catalogue). 98. E. Pound, *Cantos* (London, 1975), p. 145. 99. A. L. Coburn, autobiography, p. 88. 100. Gorham Munson, *The Awakening Twenties* (Baton Rouge and London, 1985), pp. 214–15. 101. Unsigned, "Awen or Inspirational Genius," *Shrine of Wisdom*, VI/21 (Autumn Equinox 1924), p. 21.

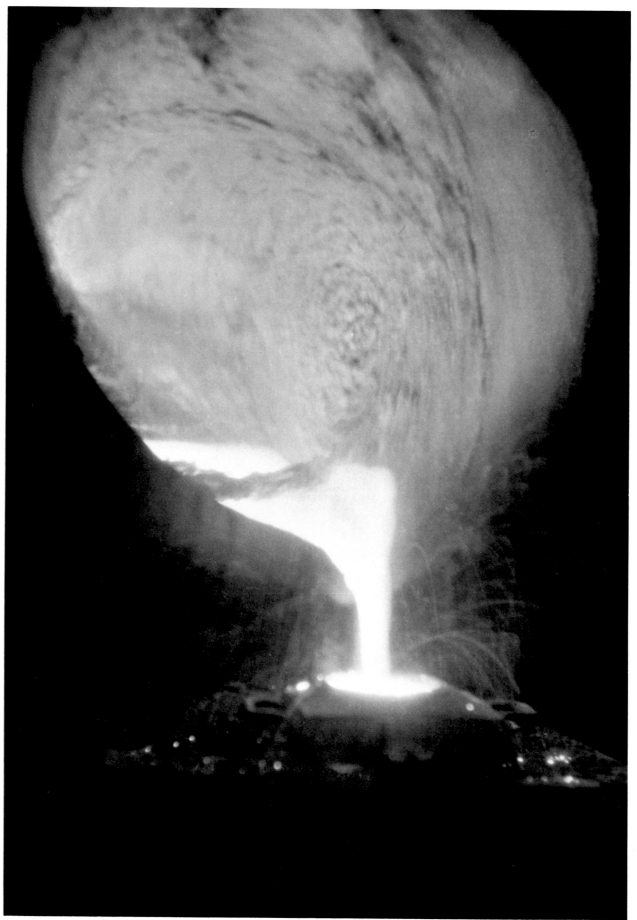

The Melting Pot, Pittsburgh, 1910

SELECTED BIBLIOGRAPHY

A complete Coburn bibliography is available from George Eastman House.

Abel, Juan C. "Editorial Comment – Alvin Langdon Coburn." *The Photographer*, vol. 6, no. 151, March 19, 1907, p. 323.

Allan, Sidney (Sadakichi Hartmann). "Alvin Langdon Coburn-Secession Portraiture." *Wilson's Photographic Magazine*, vol. 44, June 1907, pp. 251–252. Reprinted in Hartmann, Sadakichi, *The Valiant Knights of Daguerre*. Berkeley: University of California Press, 1978.

Arts Council of Great Britain. *Pictorial Photography in Britain, 1900–1920*. London: The Council, 1978. Text by John Taylor.

Blake, A.H. "The Man and His Aims III: Alvin Langdon Coburn." *The Photographic News*, vol. 52, no. 624, December 13, 1907, pp. 577–578.

Bogardus, Ralph F. "The Photographer's Eye: Henry James and the American Scene." *History of Photography*, vol. 8, no. 3, July–September 1984, pp. 179–196.

"Camera Pictures by Coburn: 'Men of Mark.'" *Photography*, vol. 36, October 7, 1913, pp. 294–295.

"Alvin Langdon Coburn." *Camera Work*, vol. 21, January 1908, pp. 3–14, 30–43. Illustrated with 12 photogravures.

Cork, Richard. *Vorticism and Abstract Art in the First Machine Age*. London: G. Fraser; Berkeley: University of California Press, 1976.

"Cornelius Agrippa." *Transactions of the Merseyside Association for Masonic Research*, vol. 29, April 17, 1951, pp. 7–15

Doty, Robert M. *Photo Secession: Photography as a Fine Art*. Rochester: George Eastman House, 1960; New York: Dover Publications, 1978.

Edgerton, Giles. "Photography as One of the Fine Arts; The Camera Pictures of Alvin Langdon Coburn, a Vindication of this Statement." *The Craftsman*, vol. 12, no. 4, July 1907, pp. 394–403.

"Frederick H. Evans." *Image*, vol. 2, no. 9, December 1953, pp. 58–59.

Gruber, L. Fritz. *Grosse Photographen Unseres Jahrhunderts*. Düsseldorf and Vienna: Econ Verlag, 1964.

Guest, Anthony. "Mr. A.L. Coburn's Vortographs at the Camera Club." *The Amateur Photographer & Photographic News*, vol. 65, no. 1689, February 12, 1917, p. 107. Reprinted in *Photo-Era*, vol. 38, no. 5, May 1917, pp. 227–228.

Harker, Margaret F. *The Linked Ring: The Secession Movement in Photography in Britain, 1892-1910*. London: Heinemann, 1979.

Hoppé, E.O. "Alvin Langdon Coburn." *Photographische Rundschau*, vol. 20, Heft 15, 1906, pp. 175–176, and 17 unnumbered pages of reproductions.

Jablow, Betsy L. "Illustrated Texts from Dickens to James." Ph.D. dissertation, Stanford University, 1978.

Johnston, J. Dudley. "Phases in the Development of Pictorial Photography in Britain and America." *The Photographic Journal*, vol. 63, no. 47, December 1923, pp. 568–582.

"The Kabbalah." *Transactions of the Manchester Association for Masonic Research*, vol. 35, 1945, pp. 28–50.

"London—Twenty Gravures by Coburn." *Camera Work*, vol. 28, October 1909, pp. 50-51, 53-55. Illustrated with one photogravure.

"Mr. Coburn's New York Photographs." *The Craftsman*, vol. 19, no. 5, February 1911, pp. 464–468.

Naef, Weston J. *The Collection of Alfred Stieglitz: Fifty Pioneers of Modern Photography*. New York: Viking Press, 1978.

"Photographic Adventures." *The Photographic Journal*, vol. 102, no. 5, May 1962, pp. 150–158. Text of address delivered January 23, 1962, at the University of Reading, for the opening of a retrospective exhibition.

Ezra Pound and the Visual Arts. Zinnes, Harriet, ed. New York: New Directions, 1981.

Pultz, John, and Scallen, Catherine B. *Cubism and American Photography, 1910–1930*. Williamstown: Sterling and Francine Clark Institute, 1981.

"The Question of Diffusion." *Semi-Achromatic Lenses Manufactured by Pinkham & Smith Company*. Boston: Pinkham & Smith, no date. Illustrations include 2 halftones after Coburn photographs.

Reeves, Amber. "The Finding of Pictures: The Work of Alvin Langdon Coburn, Artist." *The Lady's Realm*, vol. 25, no. 148, February 1909, pp. 449–459. Illustrated with 5 halftones.

D.S. "Magnificent Marksmanship." *The Bookman*, vol. 45, no. 265, October 1913, pp. 44–45.

Scott, Dixon. "The Painters' New Rival: An Interview with Alvin Langdon Coburn." *The Liverpool Courier*, October 31, 1907. Reprinted in *American Photography*, vol. 2, no. 1, January 1908, pp. 13-19.

Shaw, George Bernard. "Bernard Shaw's Appreciation of Coburn." *Camera Work*, vol. 15, July 1906, pp. 3–15, 33–35.

'Bernard Shaw, Photographer.' *Photoguide Magazine*, vol. 1, no. 9, December 1950, pp. 10–17.

"George Bernard Shaw: 26 July 1856 to 2 November 1950." *The Photographic Journal*, vol. 91, January 1951, p. 30.

The Shrine of Wisdom. Vols. 1-28, 1919–1947. Anonymous editorial board. That Coburn was a contributor, and probably an editor, is not in doubt, although the present members of the Universal Order, in accordance with the doctrine of impersonality, have declined to attribute individual contributions to Coburn.

"Substituted Secrets." *Transactions of the Merseyside Association for Masonic Research*, vol. 25, September 30, 1947, pp. 35–42.

Taylor, John. "Pictorial Photography in the First World War." *History of Photography*, vol. 6, no. 2, April 1982, pp. 119–141.

Thompson, Herbert. "Mr. Coburn's Work at Leeds." *The Amateur Photographer*, vol. 44, no. 1160, December 25, 1906, pp. 571–572.

Treasures of the Royal Photographic Society, 1839–1919. Chosen and introduced by Tom Hopkinson. New York: Focal Press, Inc., 1980. A Royal Photographic Society Publication.,

"Utopia and Freemasonry." *Transactions of the Manchester Association for Masonic Research*, vol. 46, 1956, pp. 44–63.

A Vista, c. 1906 (Plate XVIII from *Moor Park*, 1915)

CHRONOLOGY

1882 Born June 11, 1882, 134 East Springfield Street, Boston.

1887 Family moves to Dorchester, Massachusetts.

1889 Father, manufacturer of Coburn & Whitman shirts, dies.

1890 Visits maternal uncles in Los Angeles; they give him a 4x5-inch Kodak.

1891 Attends Chauncey School, Dorchester.

1897 Moves to Boylston Street, Boston, with mother.

1898 Meets distant cousin, Fred Holland Day.

1899 Crosses Atlantic with mother, taking rooms at 89 Guilford Street, Russell Square, London; F. Holland Day is living on Mortimer Street.

1900 Exhibition at the Royal Photographic Society with 103 photographs by Day, 21 by Steichen, and 9 by Coburn. Also exhibits with Linked Ring and meets Frederick H. Evans.

1901 Tours France, Switzerland, and Germany with mother.

1902 Opens studio at 384 Fifth Avenue, New York. Attends Arthur Wesley Dow's Summer School of Art, Ipswich, Massachusetts.

1903 One-man show at Camera Club of New York, January. Works with Gertrude Käsebier. Attends Dow's summer school again. Elected to Linked Ring, November.

1904 Meets George Bernard Shaw through Frederick Evans, August. Joins Frank Brangwyn's art school in London.

1905 Photographs Henry James for *The Century* magazine, April. Photographs in Edinburgh with Robert Louis Stevenson's *Edinburgh: Picturesque Notes* in mind. Meets Edward Carpenter, author of *The Art of Creation*.

1906 Begins to study photogravure at London County Council School of Photo-Engraving, Bolt Court. One-man shows at Royal Photographic Society, with catalogue preface by Shaw, and Liverpool Amateur Photographic Association, spring. Cruises Mediterranean, summer. Visits Paris, October, to work on frontispiece for New York edition of Henry James's novels; Rome and Venice, December.

1907 One-man show at Photo-Secession Gallery, 291 Fifth Avenue, New York, spring. Four photogravure illustrations for Maeterlinck's *The Intelligence of the Flowers*. Visits Charles Lang Freer in Detroit to photograph his Whistler and Oriental-art collection in Autochrome, same year process is introduced. Begins collecting prints, December, for *Colour Photography*, special number of *The Studio*, published summer 1908.

1908 Visits Dublin to photograph W. B. Yeats and George Moore; also visits Holland and Bavaria.

1909 One-man show at Photo-Secession Gallery, New York. Moves from Guilford Street to 9 Lower Mall, Hammersmith, London, where he sets up two printing presses. *London* published with introduction by Hilaire Belloc.

1910 *New York* published with introduction by H. G. Wells. Photographs in Pittsburgh, winter.

1911 Visits Yosemite, June 23–July 13; Grand Canyon, September 2– January 11, 1912. Illustrations in H. G. Wells's *The Door in the Wall and Other Stories*.

1912 Photographs in New York. Marries Edith Wightman Clement of Boston, October 11. Returns to England; never crosses Atlantic again.

1913 One-man show at Goupil Gallery, London, October. *Men of Mark* published.

1914 Arranges for Max Weber's *Cubist Poems* to be published in London. Writes in *The Bookman* about John Masefield, March, and Yoné Noguchi, April.

1915 Organizes exhibition, "Old Masters of Photography" (Hill and Adamson, Thomas Keith, Julia Margaret Cameron, and Lewis Carroll) for Albright Art Gallery, Buffalo. As a sympathetic neutral, contributes pictures to the Snapshots-from-Home League for soldiers on the Western Front.

1916 First summer visit at invitation of George Davison to Harlech, North Wales.

1917 Makes Vortographs in January; exhibits them in February at Camera Club.

1919 Becomes Freemason.

1921 Becomes Mark Mason and Royal Arch Mason, achieving Mastership in his lodges by 1930 and 1931 respectively.

1922 Becomes member of Societas Rosicruciana in Anglia. Publishes *More Men of Mark*.

1923 Meets leader of comparative religious group Universal Order, who influences him profoundly.

1924 Tours Stonehenge, Glastonbury, Wells, Cheddar, and Avebury by car.

1927 Is made honorary Ovate of Welsh Gorsedd.

1928 Loses all his Pianola rolls in flood. Mother dies.

1930 Gives up Hammersmith home and moves to North Wales. Gives his photograph collection to Royal Photographic Society. Becomes Grand Steward of England in Allied Degrees of Masonry.

1932 Becomes British subject, May 24.

1935 Is appointed lay reader of Church in Wales. Begins to contribute writings to Manchester Association for Masonic Research's annual *Transactions* and later to those of Merseyside Association.

1936 Hears D. R. Suzuki speak at World Congress of Faiths.

1937 Photographs dolmens and stone circles.

1938 Writes *Fairy Gold, a Play for Children and Grown-ups Who Have Not Grown Up*, with music by Sir Granville Bantock.

1940 Is appointed honorary secretary of Merionethshire Joint County Committee of British Red Cross Society and Order of St. John of Jerusalem, and later Honorary Treasurer and Head Store-Keeper for the Centres and Casualty Posts until July 1946.

1945 Moves from Harlech to Colwyn Bay.

1954 First of three successive winter visits to Madeira.

1957 Wife dies October 11, their forty-fifth anniversary.

1962 Largest one-man show of his lifetime organized by Professor Donald Gordon at Reading University.

1966 Dies November 23 at Awen, Ebberstone Road East, Rhos-on-Sea, North Wales.

The Death Glide, 1914